11/2002

Heaven's Window

In New Mexico he always awoke a young man. . . . He had noticed that this peculiar quality in the air of new countries vanished after they were tamed by man and made to bear harvests . . . that lightness, that dry aromatic odor . . . one could breathe that only on the bright edges of the world, on the great grass plains or the sage-brush desert.

. . . Something soft and wild and free; something that whispered to the ear on the pillow, lightened the heart, softly, softly picked the lock, slid the bolts, and released the prisoned spirit of man into the wind, into the blue and gold, into the morning, into the morning!

— WILLA CATHER
Death Comes for the Archbishop

Heaven's Window

A JOURNEY THROUGH NORTHERN NEW MEXICO

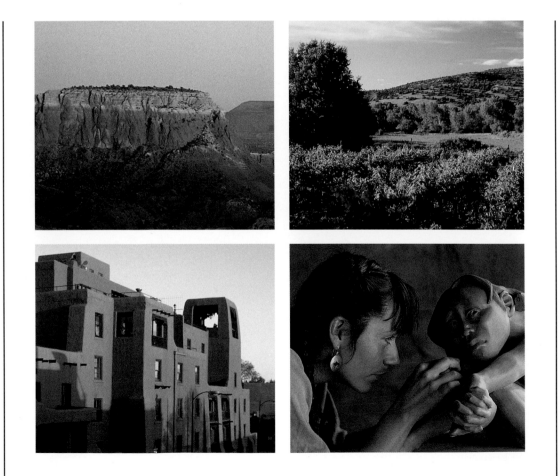

TEXT BY MICHAEL WALLIS
PHOTOGRAPHS BY JACK PARSONS

For Suzanne, the woman who gave me New Mexico,
and for Jack Potter, my mentor and friend
— Michael

For Becky and for Alex and Chris
— Jack

Photographs © MMI by Jack Parsons
Text © MMI by Michael Wallis
Book compilation © MMI
by Graphic Arts Center Publishing®
An imprint of Graphic Arts Center Publishing Co.
P.O. Box 10306, Portland, Oregon 97296-0306
503/226-2402 www.gacpc.com

Library of Congress Cataloging-in-Publication Data
Wallis, Michael, 1945-
 Heaven's window : a journey through northern New Mexico / text by Michael Wallis; photographs by Jack Parsons.
 p. cm.
 ISBN 1-55868-547-2 (HB : alk. paper)
 1. New Mexico—Description and travel. 2. New Mexico—History, Local. 3. New Mexico—Pictorial works. I. Parsons, Jack, 1939– II. Title.

F801.2 .W35 2001
978.9—dc21
 00-062316

President: Charles M. Hopkins

Associate Publisher: Douglas A. Pfeiffer

Editorial Staff: Timothy W. Frew, Ellen Harkins Wheat, Tricia Brown, Jean Andrews, Kathy Matthews, Jean Bond-Slaughter

Copy Editor: Hazel Rowena Mills

Production Staff: Richard L. Owsiany, Joanna Goebel

Design: David Skolkin

Map: Gray Mouse Graphics

Printed in Hong Kong

Photographs: Page 1: *Santa Fe sunset.* 3: *(clockwise from top left) Ghost Ranch, Abiquiu; La Chiripada Vineyard, Dixon; Roxanne Swentzell, Santa Clara Pueblo; La Fonda, Santa Fe.*

Contents

————

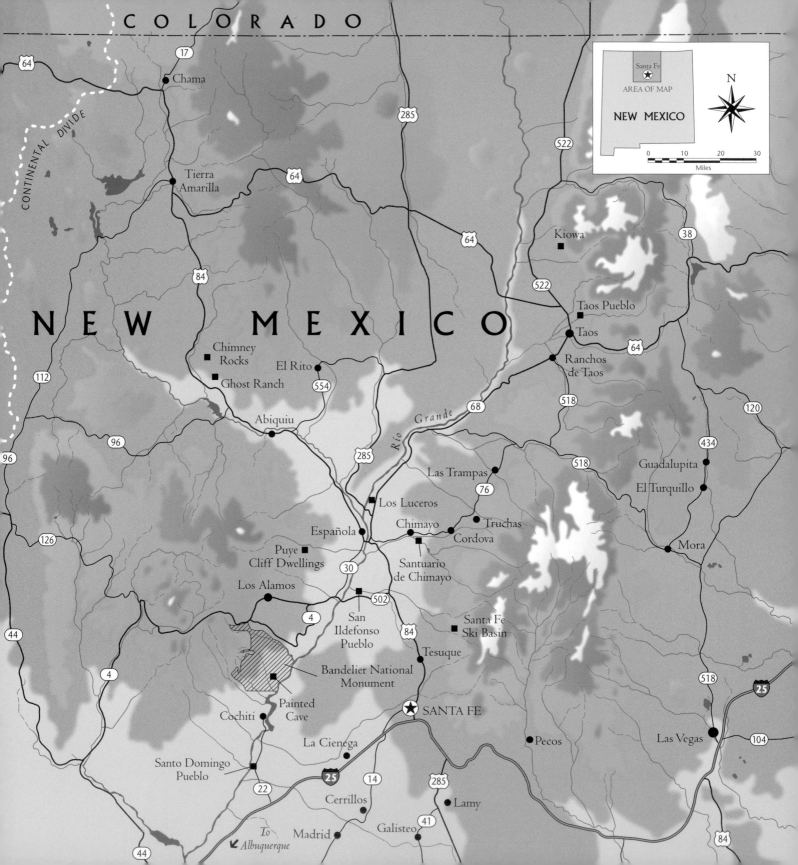

El Norte:
A Preface

I HAVE MAINTAINED A PASSIONATE LOVE AFFAIR with northern New Mexico—
frequently called El Norte—for many years. That is why, no matter how far I stray,
I always return. When I was a struggling young writer in the late 1960s, New Mexico
—in particular the mountainous north country—provided me with unforgettable adventures
and extraordinary teachers. The land and the people nurtured my creative soul. Over time, I
have found that my attraction to the land and people has never subsided but only increased.

This book offers a fresh look at a remarkable place. And I can think of no better travel-
ing companion for this journey through the north country than Jack Parsons, my creative
partner in the book and the talented photographer whose images fill these pages. A resident
of Santa Fe since the late 1960s, Jack has photographed almost every aspect of life in north-
ern New Mexico, including chile fields, low riders, and architecture. Jack's stunning photo-
graphs provide readers with a remarkably candid view of northern New Mexico.

Jack has impressive family ties to the region. Prominent in Jack's lineage is his paternal
grandmother—Elsie Clews Parsons, the pioneering feminist, renowned anthropologist, and
passionate social critic known for her work throughout the Southwest, particularly with
Pueblo Indian cultures.

Jack and I have focused our collaborative effort on the dominant cultures of this land—
Native American, Hispanic, and Anglo. Jack's photographs take in a broad range of imagery
from the region, and my narrative concentrates on specific locales and subjects, to convey an

intimate sense of the people and places of El Norte. The resulting book is from the heart. It is our take on the place—some of our favorite stories and visual memories of this land of high drama, this place that continues to delight and mystify.

El Norte, especially the high country of Santa Fe and Taos and the surrounding countryside, truly is a window into heaven. And if there really is a celestial heaven, there can be no better entrance than the irregularly shaped "window" of northern New Mexico.

MICHAEL WALLIS
Santa Fe, New Mexico
August 2001

Prologue

I SHALL NEVER FORGET a man from Taos Pueblo who passed through my life like a shadow long, long ago. It was late in the day when our paths crossed in a patch of sunlight on the edge of the Taos town plaza. He stopped me with a gesture and I lit his cigarette. The man, basking in the uncertain warmth of a winter sun, nodded his thanks but maintained his proud bearing. I said something inane about the weather. There was no response. I was just about to walk away when he did speak.

"We were here long before the Spanish came," he said in a nonchalant way, as if we had been visiting for hours. "And we were here long before the Anglos."

I acknowledged that he was right.

He spoke again. "We will be here long after the Spanish and Anglos have gone." There was not a hint of threat in his monotone voice.

He took another drag on the cigarette and slowly exhaled the smoke. Then the man—with long braids, and swathed from head to knee in a blanket—looked at me directly for the first time.

"Do you know where I live?" the man asked.

"I imagine you live out at the pueblo," I said.

"I live at the top of the earth," he told me. "Don't you know where you are? You are at the top of the earth." Then he turned and walked away.

I watched him until he was out of sight, swallowed up by twilight and the dark mountain.

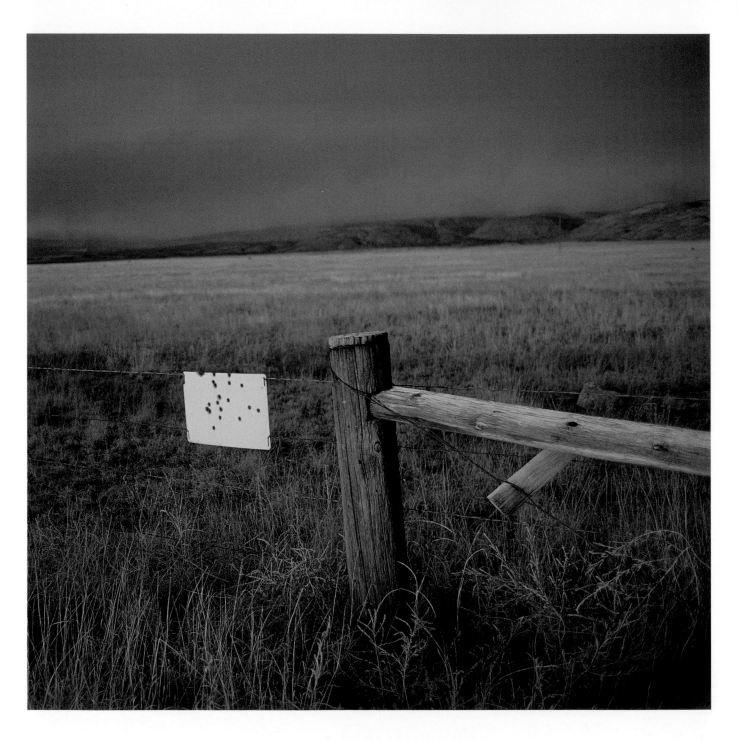

Fence line near La Bajada, east of Cochiti Pueblo.

Center Stage in Santa Fe

*T*HE DAY I MOVED away from northern New Mexico, I drove out of Santa Fe and never looked back. I did not even steal a glance in the rearview mirror. I could not stand to see the receding mountains, the heavens, and all the places of El Norte — grand and ordinary — that had become so much a part of me.

By the time I hooked a left turn onto the interstate highway and returned to the so-called real world, my soul ached. I had turned my back on the eternal and everlasting northern New Mexico — a region that had given me shelter and sustenance and so much more.

Nobody told me to leave; I left because I had no other choice. The atmosphere around me had become stifling and thick from the richness of life, spiritual incest, and high-octane dreams. I could no longer breathe.

I had heard the warnings. I recalled others telling me about the powerful aura of the place and how it had been the downfall of so many artists. The sunlight, the space, the silence had worked their spell on me. I knew only poets, painters, dropouts, dreamers, shamans, and wizards. I spent my time with carvers of santos, dispensers of magic, and expatriates from every corner of the globe. All of it was inspiring and so seductive. Now I had to come up for air and gulp in enough to clear my head, to become who I wanted to be.

As it turned out, I was lucky. Beyond the boundaries of my sanctuary, I honed my writing skills and found still more good teachers.

Looking southwest from Santa Fe across Rancho Viejo toward the Cerrillos,
the Ortiz, and the Sandía Mountains.

Eventually, when I felt I was ready and the time was right, I came back to Santa Fe and northern New Mexico. I came home to Taos and the necklace of mountain villages and the pueblos dotting the banks of the Río Grande. I had learned how to breathe — steady and even. I became aware of the rhythms of the people, the language of the land. I discovered how to listen. And while living in the here and now, I learned from the past — from the layers of history and my own beginnings with the place.

All these years later, I still recall the first time I entered Santa Fe. My arrival came at the tail end of the turbulent and remarkable 1960s. I showed up with nothing but a pair of exhausted Marine-issue combat boots and a seabag stuffed with a few possessions.

Like a wild-eyed conquistador with a poet's heart, I laid claim to everything I encountered. Like so many others before and since who have come to this land, I paid my dues so I could stay. I waited tables, labored at a dude ranch, managed a ski lodge, and tutored artistic Indian teenagers. I edited a literary magazine, took to the stage, and found out more about the process of writing than I had at any university. Santa Fe became my campus, and I learned my lessons at places either vanished or transformed from men and women now long gone.

I met Frank Waters, Georgia O'Keeffe, Dorothy Brett, Andrew Dasburg, Fremont Ellis, Gustave Baumann, Paul Horgan, Bill Lumpkins, and so many more of the old guard who were still there — the artistic forces who helped create images of northern New Mexico that persist to this day. I came to know Tommy Macaione, "El Diferente" — the remarkable Santa Fe character with a wild mane — who lived with dozens of cats and dogs and painted stunning impressionist landscapes.

I stalked the mountains — the Sandías, the Jémez, and the Sangre de Cristos. I fished the Pecos and damn near died in the untamed parts of the Río Grande. I found eagle feathers and fresh cougar prints. I watched black bears silently pad down Santa Fe streets in search of a cool drink of water. I became acquainted with magpies and roadrunners smarter than most human beings.

I cooled off in the waters of hand-dug acequias, or water ditches, older than most American cities. I sat at the deathbed of an old woman who recalled having seen as a child the funeral procession of controversial Archbishop Jean-Baptiste Lamy. I danced at the feet of Zozobra — the huge effigy of gloom and despair that is burned at the start of each Santa Fe Fiesta. I conversed with owls in camposantos — burial grounds lined with mounded graves shrouded in plastic flowers from Wal-Mart and brittle crosses disintegrating under the searing sun and dry winds. I watched Pueblo Indian dancers sway as one to the tattoo of timeless drums. I learned that good chile is more potent than penicillin.

I rode low and slow with low riders in their gleaming cars through the streets of Española.

I sucked in piñon smoke as if it were holy incense. I smoothed my palm over petroglyphs — graffiti etched in stone by ancient peoples. I parked my pink-and-white Ford Ranchero

Every September, a forty-foot-tall puppet named Zozobra, representing Old Man Gloom, is burned amid cheers from the assembled crowd. This event opens the annual Fiesta de Santa Fe.

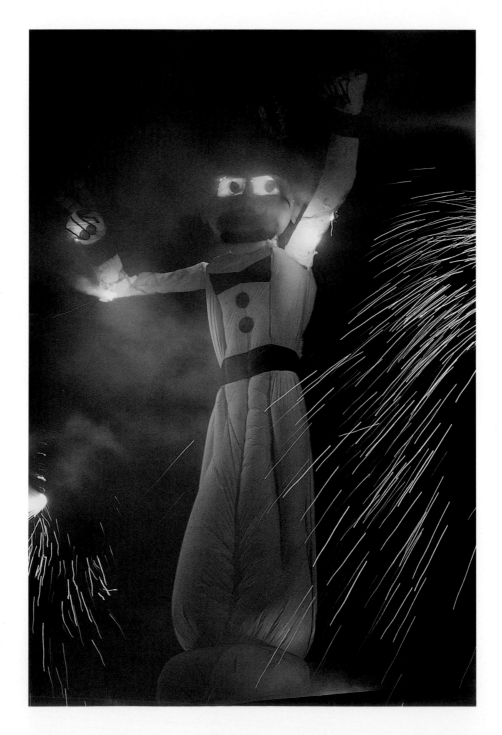

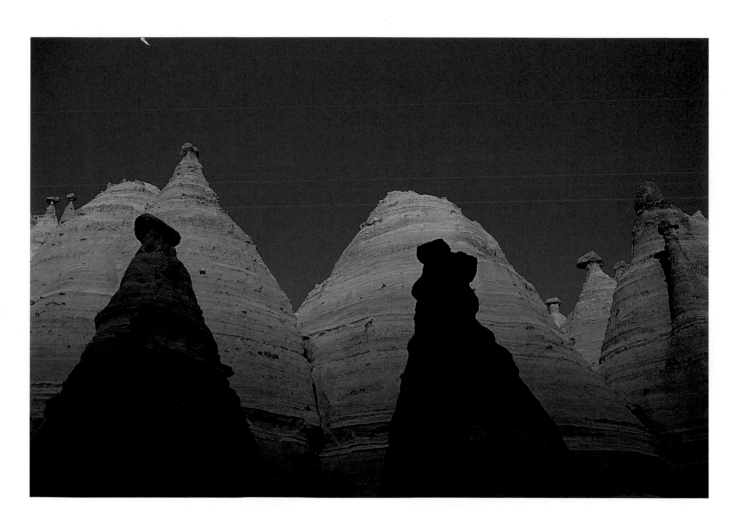

*Kasha-Katuwe Tent Rocks has been designated as a new National Monument. West of Santa Fe near Cochiti
Pueblo, the strange and wonderful shapes are composed of pumice and tuff deposits from ancient volcanoes.*

named El Coyote on a trail high in the Sangre de Cristo Mountains and never found it again.
I stalked rainbows that stretched back to the beginning of time. I rubbed the adobe earth into
my hide. I became a moon hunter. I drank snowmelt beneath evergreens that climbed slopes
once cloaked in glacial ice.

I dined with a reincarnated Indian princess. I leaped over a bonfire in Tesuque with Bill
Mauldin, the GI Joe cartoonist. I witnessed Maria Benitez perform her flamenco at El

Nido—"The Nest"—and stir the hidden desires of every man and woman there. I spent untold hours in the Sombrero Bar, long vanished from the Plaza at Santa Fe, with a man whom a young Ernest Hemingway had taught to box in Paris.

I lived with ghosts.

I watched the classic dance of planets in the night sky and worshiped star clouds. I wired for sound San Miguel Mission, the oldest church in the nation. I passed time in ancient villages, pueblos, communes, and ghost towns. I visited fancy hotels and observed dowagers and manicured dandies dripping in turquoise and silver. I walked with saints and looked the devil right in the eye. I absorbed the nuances of history and culture. I bathed in the intensity of visible light flooding through the rarefied mountain air. I held hands with a bona fide witch. I found countless mentors, wisdom keepers, and bold lovers.

I promised myself that I would die in this land.

As soon as most people enter northern New Mexico, they realize they have come to a special place. That certainly was true for me back in the born-to-be-wild summer of 1969, when I first slipped into Santa Fe.

As I drove north on the highway from Albuquerque, the great rock bluff called La Bajada suddenly rose before me. I realized I had reached a place of major transition. I was leaving the Río Abajo, the meandering lower river, and the southern reaches of the Río Grande valley. Behind me stretched the parched mesas and painted mountains of the south. Above me waited the north country—Río Arriba, the upper river, cutting through a deep, rocky gorge.

The car strained up the steep hill, panting in the thin air. And there at the summit of the commanding lava plateau, my eyes beheld for the first time the imposing and colorful Sangre de Cristo Mountains—"the blood of Christ"—and the city of Santa Fe spilling out from the range.

That image of cloudscape, the play of celestial light and the nuance of shadow on the soft purple mountains, and the ancient city below has never left my memory. The high desert scene before me was extraordinarily beautiful. In a heartbeat, I saw how different northern New Mexico was from any other place I had ever been. The landscape with its dramatic mountain backdrop seemed exotic and foreign, yet inviting. The pungent aroma of juniper and sagebrush swept into the car.

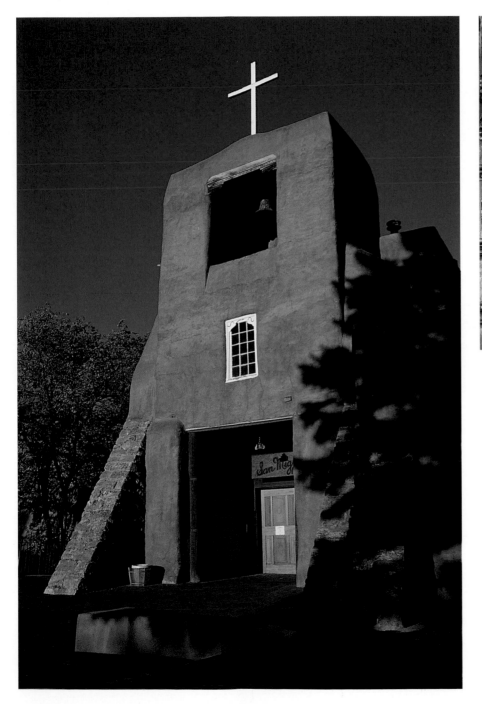

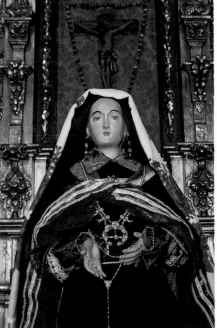

(Left) San Miguel is considered by some historians to be the oldest church still in use in North America.

(Top) The statue, La Conquistadora, Nuestra Señora de la Paz, *was brought to Santa Fe in 1625. She now resides in a chapel adjacent to St. Francis Cathedral.*

I pressed on, racing up the same path known by other names, including El Camino Real and Route 66, and entered Santa Fe. I passed the adobe houses, gas stations, fast-food joints, and the commerce and clutter along Cerrillos Road without a second glance. I did not stop until I found the Old Pecos Trail and then the Santa Fe Trail snaking into the Plaza—the historic heart of the city.

It was simple for me. I told my friends I had found a refuge. Snug at seven thousand feet against the timeless mountains, Santa Fe, the oldest capital city in the United States, appeared to be a place that did live up to its nickname — "The City Different." I settled in, and set out to memorize the land and the people and learn all the secrets.

At first, as most newcomers tend to do, I bought into the myth of Santa Fe. I allowed the fabrications and fables to influence me. I became totally entranced. And like so many others before me—all the way back to the time when Santa Fe was only a hamlet in the mountains— I became possessive of my adopted home. I viewed the city—*my* city—as a kiva, an underground ceremonial chamber where the Pueblo people hold their rituals. I wanted to pull in the ladder behind me and not allow anyone else to enter my sacred, secret hideaway.

In truth, Santa Fe never was a secret. Early Native American people—the first New Mexicans—lived here thousands of years before anyone else. They built villages in the vicinity of present-day Santa Fe hundreds of years before the first Spanish colonists thought about settling in the picturesque foothills. Those tribal people then apparently vanished from the immediate area, because archaeological evidence indicates that when the Spaniards established Santa Fe in the early 1600s as the third capital of the colony of New Mexico, they built on the site of an abandoned pueblo. And from their newly founded settlement on the banks of the Santa Fe River, the Spanish ventured forth into the countryside and established their presence among the outlying Pueblo peoples. I find it ironic that my Hispanic friends complain about all the Anglos moving into their land when their own ancestors did the same thing to the Native Americans.

Since that early epoch, Santa Fe has constantly been discovered and rediscovered. Some families have lived in the city for at least fourteen generations, but a steady flow of newcomers continues. Invaders have come on foot, horseback, and in recreational vehicles and Land Rovers. They have ranged from conquistadores with a cross in one hand and a sword in the

(Opposite) Cerro Gordo road on Santa Fe's east side.

other to marauding bands of Plains Indian warriors who preyed on Pueblo people and Spanish colonists. Other intruders include conquering armies, traders and merchants, hippies, slick land promoters, and affluent southern Californians who frequently prefer sushi to green chili stew.

The old city and all it offers have always mesmerized me. Still, after I wisely left and then returned, I was able to develop an honest relationship with this place. I accepted the flaws and cherished the perfections.

I spent time with friends in Tesuque, a picturesque community named for nearby Tesuque Pueblo on the edge of Santa Fe. I hung around in the funky chic eastside neighborhoods of

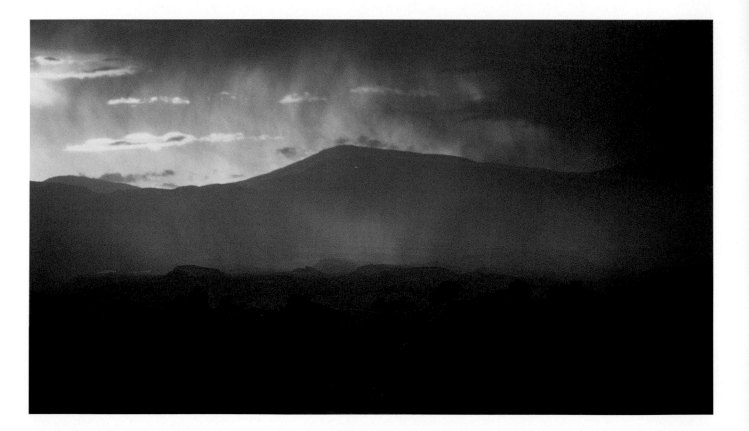

A summer rainstorm in Tesuque with the Jemez
Mountains in the distance.

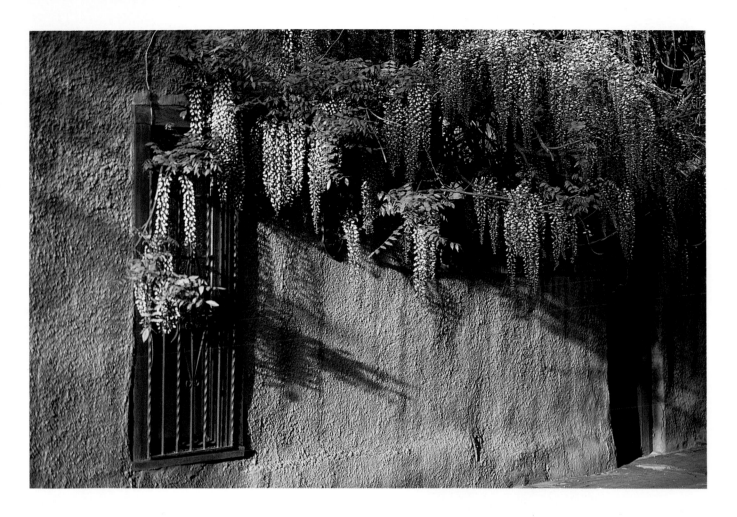

Wisteria overhangs an adobe wall on Santa Fe's East De Vargas Street.

Santa Fe flanking streets such as Camino del Monte Sol, Acequia Madre, and Canyon Road, where struggling artists and aspiring artists banded together to rent rooms or apartments. I also acquainted myself with the barrios and subdivisions where state government workers raise families and flock to shopping malls. I read the steady stream of glossy magazine pieces and travel stories extolling the skiing, galleries, museums, restaurants, and shops. I came to understand that Santa Fe had become a city that often believes its own publicity.

As a result, Santa Fe promises and delivers pure theater. Occasionally it is melodrama; sometimes it is absolute burlesque. The actors come and go and some of the sets change, but that backdrop of luscious mountains and parched high desert remains constant. So do the firs and the aspen groves — with leaves like shimmering gold coins in autumn — scattered through

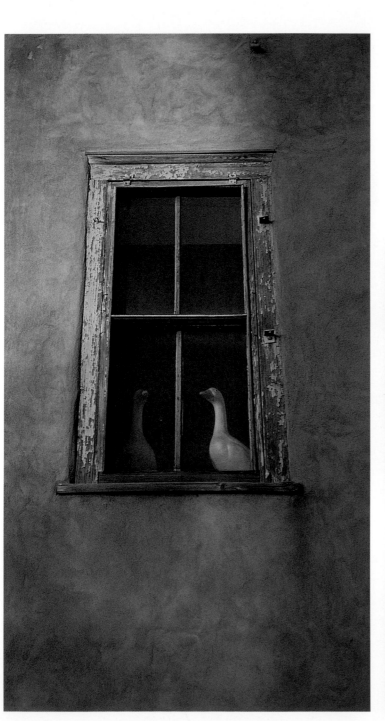

(Left) Two geese survey the scene from Doodlet's on Don Gaspar Avenue in Santa Fe.

(Bottom) Rusty Rutherford is the owner of the world's largest sombrero collection, in downtown Santa Fe.

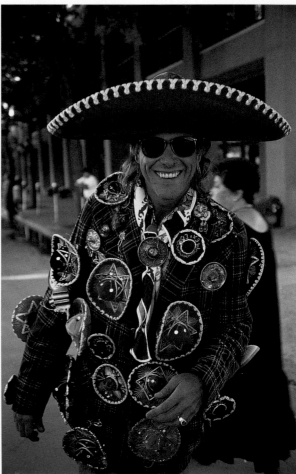

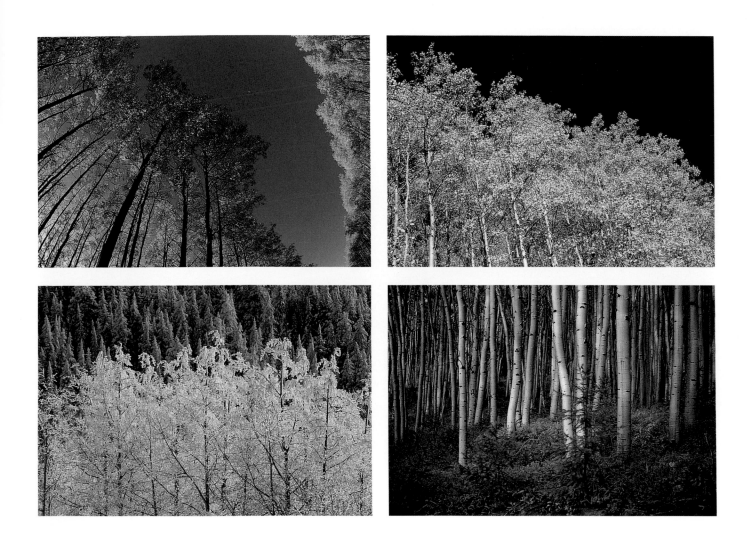

Aspens in the Sangre de Cristo Mountains above Santa Fe
in (clockwise from top left) fall, spring, and winter.

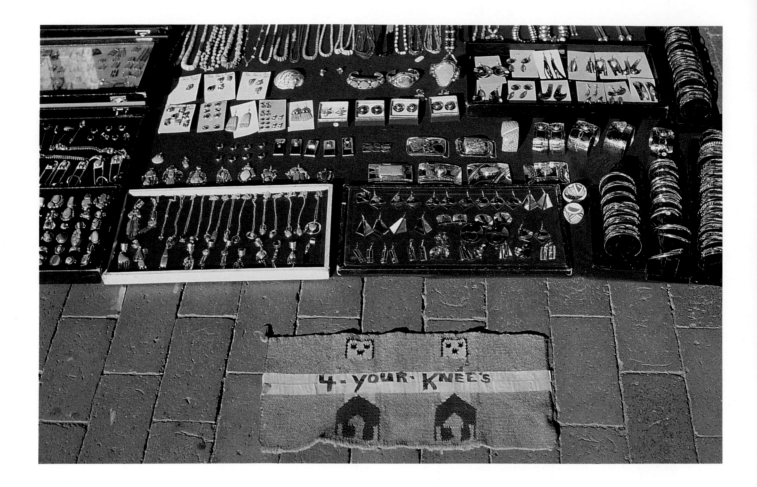

*Native American vendors along the front of the Palace of the Governors thoughtfully
provide a place to kneel while tourists decide what to purchase.*

the high mountain forest. Living bouquets of chamisa grace the borders of roads and arroyos,
and the fragrant scent of burning piñon wood permeates the air. Taken together, the natural
architecture makes an exquisite setting.

No matter the quality of the performance, one certainty is that center stage is always the
city's main Plaza. Laid out by Spanish interlopers as early as 1607, the year La Villa Real de
Santa Fe de San Francisco de Asís, "The Royal City of Holy Faith of St. Francis of Assisi,"
was founded, the original Plaza was much larger than it is today. Nonetheless, it still serves as

the social and commercial hub for the city. More historical events have occurred on this site, called La Plaza de Armas in the seventeenth century, than in any similar place in the Southwest.

Four flags have flown over the Plaza—Spanish, Mexican, Confederate, and United States. The Plaza has been the site of bullfights, public floggings and executions, gun battles, political rallies, and fiestas. A haunt for mountain men and traders journeying on El Camino Real from Mexico, the Plaza also marked the end of the famous Santa Fe Trail. On more than one occasion, motion-picture lights and cameras kept the Plaza's pigeons awake all night. Here the elegant and the ordinary brush shoulders, often without knowing. Movie stars and poets cross paths with ski bums and camera-toting tourists from Dallas and Des Moines.

In the Plaza, find an empty spot on a wrought-iron bench and take a seat. Several distinct architectural styles—including Pueblo Spanish, Pueblo Revival, Mission Revival, and Territorial—are plainly evident in the buildings bordering the four sides of the Plaza. If you are lucky, a feeling of the present may give way to the past. Feed the pigeons and watch the procession of people. Breathe steady and evenly. Allow the many spirits that congregate in this open-air museum to touch you.

Look at the commemorative monuments on the Plaza. A granite marker near the southeast corner, erected in the early 1900s by the Daughters of the American Republic, marks the end of the Santa Fe Trail. In the exact center of the Plaza stands an even older obelisk, erected in 1868 in honor of those who fought in the Civil War and the Indian wars. All property surveys in the city's original land grant use this monument as their ground-zero point.

Known as the only monument in the United States that uses the word *rebel* to describe Confederate soldiers, this National Historic Landmark became more and more controversial. I remember the August day in 1973 when a young man with a blond ponytail and wearing a hard hat took umbrage with a word used in an inscription that saluted "the heroes who have fallen in the various battles with savage Indians in the territories of New Mexico." The self-appointed critic chiseled out the word *savage* in what was described as an act of political revisionism.

Running the full length of the Plaza's north side is the Palace of the Governors, a simple adobe structure, built in 1609–10 that housed the first state capitol in the United States. The nation's oldest continuously occupied public building, it is now a museum.

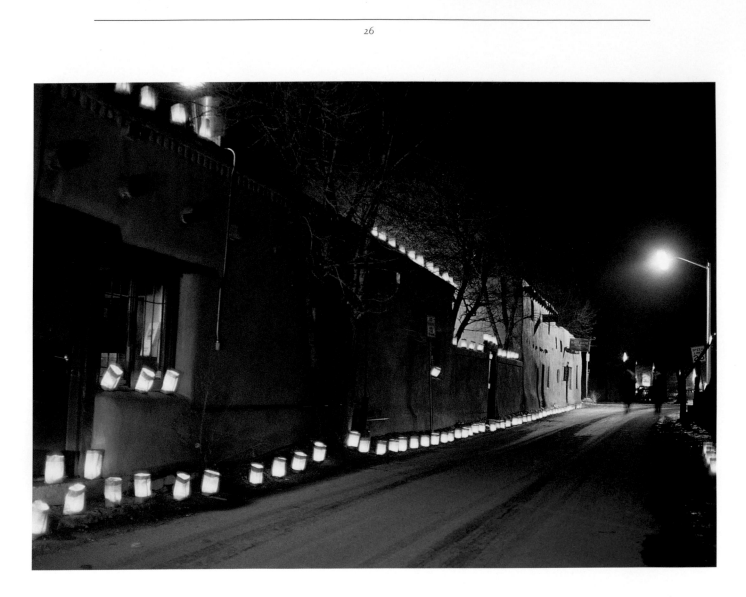

Farolitos *line De Vargas Street in Santa Fe*
at Christmastime.

If one accepts the premise that the timeworn Plaza is indeed the heart of Santa Fe, then surely La Fonda, the hotel that dominates one of the Plaza's corners, is the essence of the city's exuberant soul. The architecture, history, furnishings, and ambience of this structure reflect the development of the city as well as the culmination of the Indian, Hispanic, and Anglo cultural mix unique to the region.

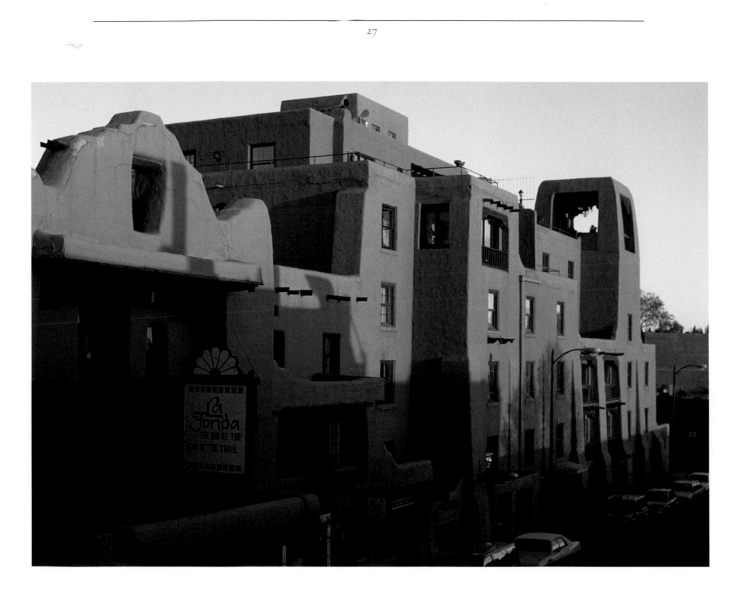

La Fonda, built in the 1920s on the southeast corner of the Santa Fe Plaza,
marks the end of the Santa Fe Trail.

The first night I ever spent in Santa Fe was in one of the guest rooms at La Fonda. Even then, when I did not have two dimes to rub together, that night at La Fonda was worth the splurge. That evening, wrapped in my true love's arms in a hand-painted bed in a room overlooking the Santa Fe Trail, I consummated my relationship with the city.

For me, La Fonda will always be Santa Fe's living room. When I was struggling to become

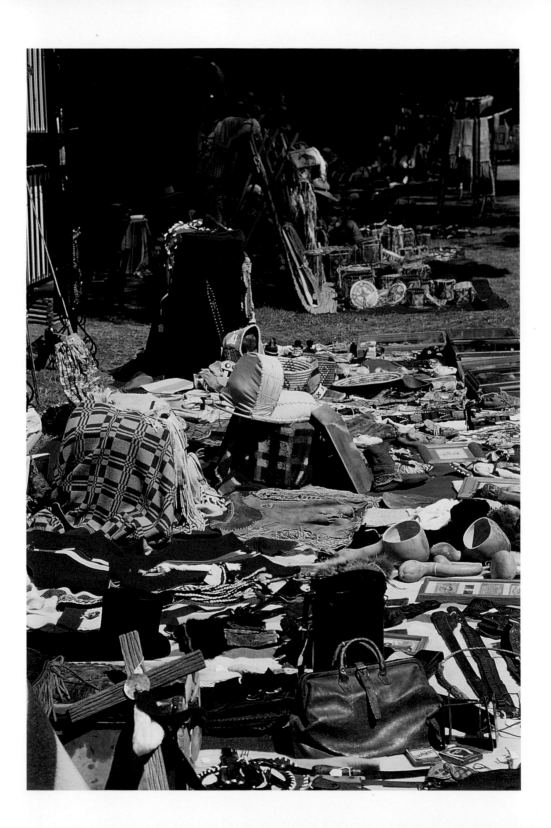

(Opposite) Mountain men and traders fill the courtyard of the Palace of the Governors with their wares during the annual August buffalo roast.

(Clockwise from top left) Agnes Martin, renowned woman artist, at her studio in Taos. William Lumpkins, pioneering New Mexico solar architect and acclaimed artist, at his studio in Santa Fe. Tommy Hicks, owner of the Shidoni Foundry and Gallery in Tesuque.

Christmas in Santa Fe. (Left) A gate adorned for the holidays on Garcia Street.
(Right) A snowy adobe on Canyon Road.

a writer, I made it a habit to spend at least part of every day at La Fonda. It usually proved to be time well spent.

For instance, there was an autumn afternoon in 1971 that brought me to the hotel on the Plaza. It had been a difficult day. Hours of wrestling with words at my typewriter had taken a toll. Finally, my work gained the upper hand, and I left my cramped apartment not far from the Plaza to run my daily trapline.

The nearby post office box yielded no checks, only junk mail and more polite rejection slips from editors. I remembered the few dollars stashed in my wallet, and La Fonda crossed my mind. The hotel on the southeast corner of the Old Santa Fe Trail and San Francisco Street would help cure the blues.

After walking a few blocks, I reached the shady Plaza, crowded with tourists, resting backpackers, and dogs wearing neckerchiefs. The aroma of roasted piñon nuts wafted through the air and mixed with the perfume of patchouli. Beyond the trees, I spied La Fonda rising into the cobalt blue sky.

Inside the lobby, I breathed a sigh of relief. I greeted the bellmen who had worked there since before I was born, and I headed directly to the cantina.

The tables were beginning to fill with early arrivals for cocktails, but a solitary stool remained at the bar. Another journeyman writer was keeping bar. He had a reputation for pouring strong drinks. Miraculously, my glass of whiskey always stayed topped off, as did a brimming reservoir of chili con queso and baskets heaped with tortilla chips, hot from the nearby kitchen. For a couple of bucks, I could drink and eat like a prince while I listened to soft serenades.

I had just raised my glass in a *salud* to the approaching evening when the bartender told me a distinguished author had checked into La Fonda the night before. "He's your kind of writer. I told him all about you. In fact, here he comes now. I'll introduce you."

I put down my glass and rose to greet an elderly bespectacled gentleman with a neatly trimmed moustache. As my friend introduced us and stated our names, I was stunned to learn that I was facing a literary legend. Standing before me was Thorton Wilder, winner of three Pulitzer Prizes, author of such works as *Our Town*, *The Skin of Our Teeth*, and *The Bridge of San Luis Rey*.

We sat, and in the glow of the soft candlelight, I became oblivious to the cantina chatter and the strumming guitar, as Wilder explained that he was on a pilgrimage. He had returned

to northern New Mexico to reacquaint himself with the land that had enchanted him ever since the 1930s, when he spent time with Mabel Dodge Luhan, the art lioness who had held court at her salon in Taos for many years.

Wilder kept me spellbound. Well into the evening, he regaled me with intriguing accounts of Mabel and of Dorothy Brett, Thomas Wolfe, Leopold Stokowski, Spud Johnson, Robinson Jeffers, and Witter Bynner. Hours vanished like minutes as Wilder spoke of high and low times past in Santa Fe and Taos.

Less than four years later, this revered man of letters died in his sleep at his home in Hamden, Connecticut. But that evening in La Fonda as he talked to me, it was clear that he still knew the worth of life and was hungry for knowledge. Here was someone who had learned how to breathe.

Wilder shared more of his wisdom and wit. He suggested books to read, and he offered invaluable writing advice. I dashed off notes on a stack of cocktail napkins. A man of modesty and grace, Wilder asked as many questions of me as I asked him. The night became a satisfying exchange between master craftsman and novice.

The encounter with Wilder reinforced my premise that if the word "serendipity" ever applied to an edifice, it would have to be associated with La Fonda, where chance meetings often lead to a windfall of blessings. If someone wishes to enjoy a memorable tête-à-tête, find a lost friend, catch a glimpse of a famous person, or just indulge in some old-fashioned people-watching, all he needs to do is settle into a comfortable chair in the lobby of La Fonda. The Spanish mission–style hotel acts as an elegant but cozy gathering place for locals, film crews, authors and artists and, of course, multitudes of turistas. People from all stations of life feel at ease there. The hotel staff likes to boast, "The world walks through our lobby." Maybe so. I remain convinced that if you sit in the lobby long enough, you will see everyone you have ever met.

La Fonda is also important because it stands as a symbol of the merger—actually the collision—of old and new Santa Fe. To truly comprehend what Santa Fe was and what the old city has become, for better or worse, it is useful to track the history of what we now call La Fonda.

(Opposite) A young girl dances at the spring festival at El Rancho de Las Golondrinas.

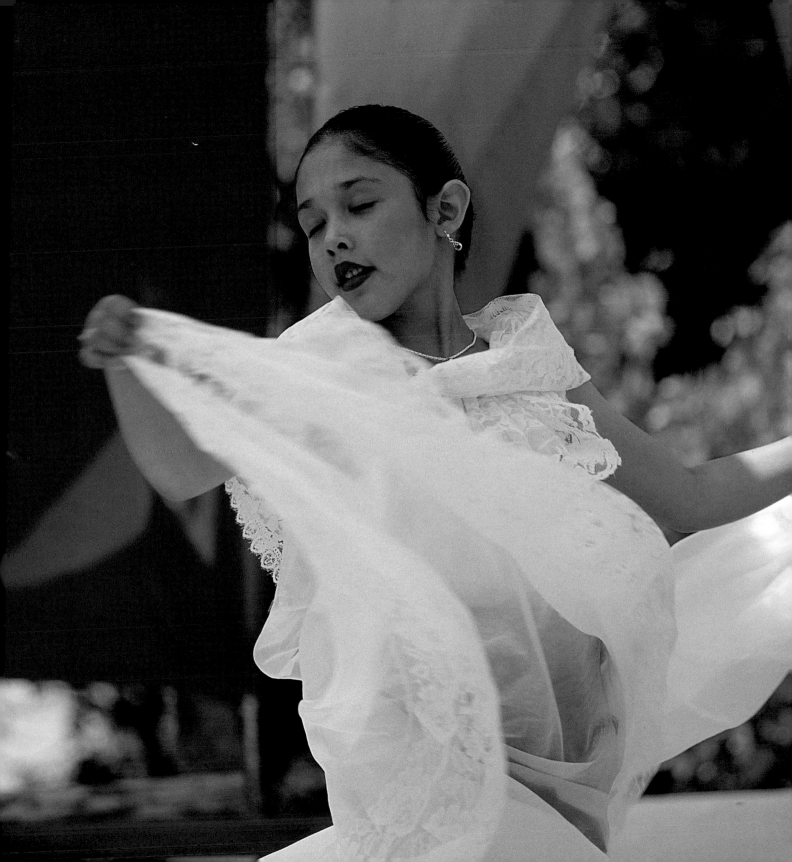

(Clockwise from top left) Patricia Lafarge's vast
collection of Mexican folk art. A door covered
with milagros at Nedra Matteucci's Fenn Gallery.
Spanish Market artist Frank Alarid's retablos in
his kitchen studio.

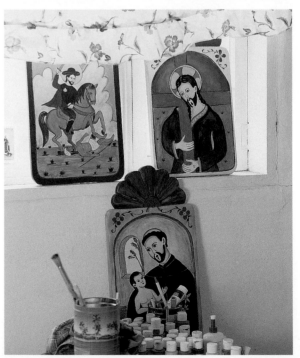

The present version of La Fonda appeared on the Plaza in the 1920s and increased in size in later years. But it is known that there was an inn on the site not long after Don Pedro de Peralta and the conquistadores founded Santa Fe almost four centuries past, making it the oldest hotel *corner* in the United States. A private residence stood on the Plaza corner in the mid-1700s. Through the years, this domicile with a *zaguán*, or outside entry wide enough for a wagon, became known as La Fonda.

There are references to the hotel in the writings of various adventurers attracted to Santa Fe. For example, Zebulon Pike, busy prowling the Rocky Mountains and exploring the Colorado peak that bears his surname, was well aware of the prominent inn. Spanish troops captured Pike near Santa Fe in 1806. Local authorities charged him with spying and tossed him into a dungeon at the Palace of the Governors, on the Plaza. After his release, Pike noted in an 1807 journal that during his incarceration in Santa Fe, he saw a thriving inn—undoubtedly, La Fonda.

Anglos entered the territory in numbers in the early 1820s after Mexico won independence from Spain and the legendary Santa Fe Trail opened. Specific references to the hotel were scrawled in diaries and journals of stalwart merchant traders who made the journey across the plains separating Missouri and Santa Fe. The hotel at the end of the trail became a welcome sight for those who had endured months of hardship. Captain William Becknell, a pioneer trader, reported that he and his party found comfortable quarters and tasty food at the adobe inn on Santa Fe's teeming and dusty Plaza. The discovery of gold in 1828 in the Ortiz Mountains south of Santa Fe also brought more business to the hotel—especially the casino and cantina.

That often vile and profane town teeming with traders, rooster fighters, soldiers, whores, and fortune hunters did not bear much resemblance to the alluring tourist haven we now know as Santa Fe. Anglo-Americans who flocked to Santa Fe came upon a culture that shocked them. The Hispanic women of the city more often than not smoked cigarillos, danced the fandango, and gambled in public. Some local women even owned their own businesses, something almost unheard-of in the Anglo world of commerce. Catholic priests routinely and openly took mistresses. Places of business, including hotels, served as fitting reflections of their clientele.

By 1846, when war erupted between Mexico and the United States, the hotel saw an influx in business. Much of this resulted from the arrival of more gringo soldiers, when General

the money to purchase the property and finance the construction of an even grander hotel on the historic site.

In his book, *Santa Fe: The Autobiography of a Southwestern Town*, Oliver La Farge gave special attention to the inception of the present La Fonda, a monumental civic undertaking resulting in "one of the handsomest hotels" in the nation. "The achievement is one never before equaled in New Mexico," reported the Santa Fe *New Mexican*. "In two weeks time a community of not more than 8,000 souls raised nearly a quarter of a million dollars to boost the Old Home Town. . . . The result is the biggest thing Santa Fe or any other town has ever done and assures the steady growth and prosperity of the city."

At long last, La Fonda became the hotel's official name. The new Spanish Pueblo Revival building designers were Rapp, Rapp, and Hendrickson. This same architectural firm created Santa Fe's Museum of Fine Arts building, which had opened on another Plaza corner in 1917. The preservation of Santa Fe's past style of traditional adobe architecture resulted in transforming the Victorian buildings on the Plaza and elsewhere into Pueblo Revival and Territorial-style mercantile houses. With a combination of adobe walls, flat roofs, and exposed vigas, the large museum building helped originate what became known as "Santa Fe style."

Built in an L shape, the new La Fonda was one-half block deep and more than one-half-block wide with four stories, forty-six rooms, balconies, towers, and terraced roofs. Cement stucco the color of adobe covered the hotel's thick walls, constructed of reinforced concrete and hollow tile, like many of the Santa Fe–style structures.

Despite some difficulty in finding a competent manager and locating adequate furnishings for all the guest rooms, La Fonda officially opened for business on December 30, 1922. All those in attendance declared the event a smashing success. But the good times of those early years in the Roaring Twenties were short-lived for the hotel. Only two years later, La Fonda closed because of serious financial difficulties. It sat empty for two more years.

Fortunately, in 1925, the Atchison, Topeka, & Santa Fe Railway acquired the property, which it leased to the Fred Harvey Company the following year. La Fonda became a Harvey

*(Opposite) The Museum of Fine Arts in downtown Santa Fe is
a superb example of Pueblo Revival architecture. Completed in 1917,
it houses a vast array of traditional and contemporary work.*

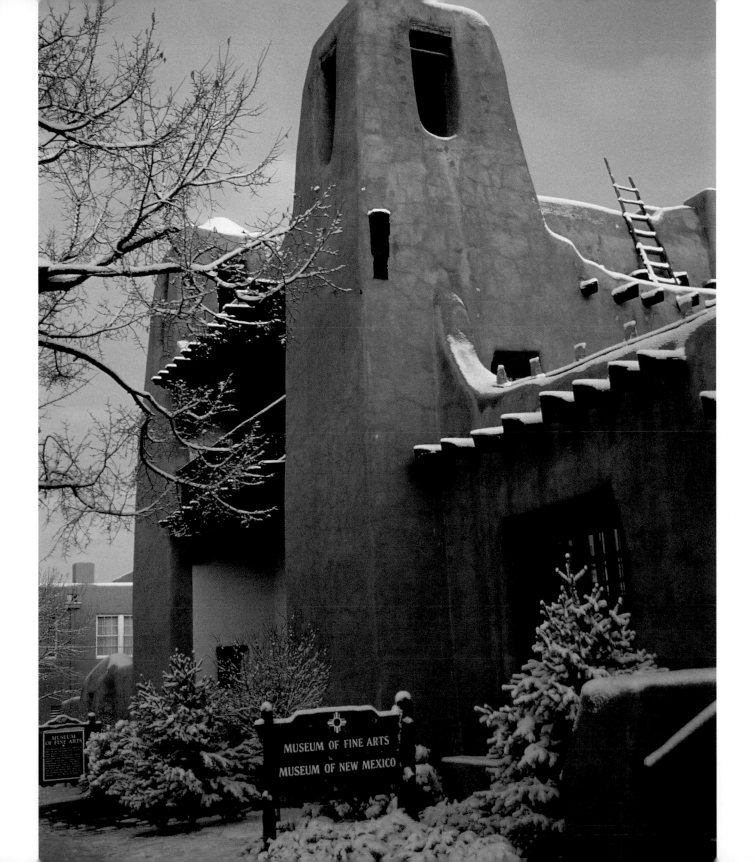

MUSEUM OF FINE ARTS
MUSEUM OF NEW MEXICO

House, and from that time forward the oldest hotel corner in the nation enjoyed nothing but success. For more than forty years after the Harvey family took the reins, La Fonda shone as a gem in the chain of Harvey Houses or, as one newspaper described it, "the jewel of the entire collection of railroad hotels in the Southwest."

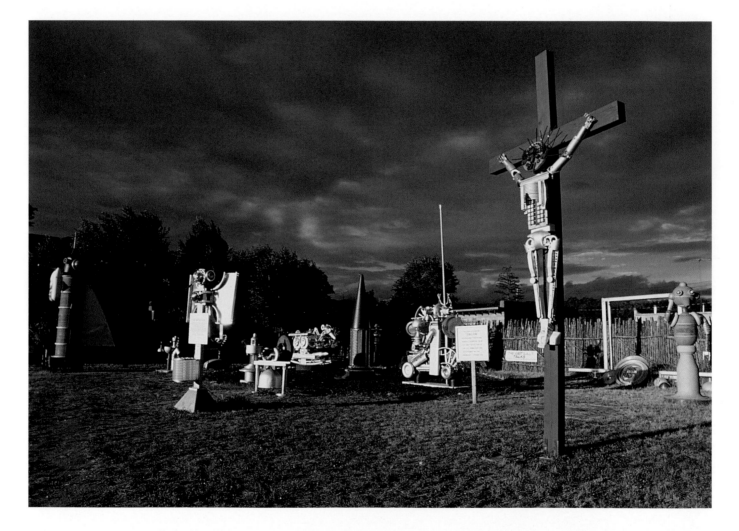

A series of sculptures has been created by the "atomic artist" Tony Price. His work fashioned from cast-off materials salvaged from Los Alamos makes a powerful statement about the use and proliferation of nuclear arms.

It was often said that Fred Harvey had a greater impact on the American West than "Wild Bill" Hickok or Wyatt Earp. Born in England in 1835, Harvey moved to the United States when he was just fifteen. After many years spent working his way westward from New York, he ultimately entered into an agreement with the Atchison, Topeka, & Santa Fe to provide food service at its depots.

Soon, the entrepreneurial Englishman opened a series of first-rate restaurants that eventually stretched along thousands of miles of railroad lines across the West. Harvey Houses were renowned for their appetizing cuisine at reasonable prices, as well as for the efficient young ladies known as Harvey Girls, whom the company recruited as waitresses.

By the time of Fred Harvey's death, in 1901, his hospitality empire included dining-car service, fifteen hotels, and forty-seven restaurants. The company continued to expand thanks to Harvey's sons, grandsons, and other family members, who maintained his legacy. More important, the Harvey Company, along with the Santa Fe Railway, pioneered the use of modern advertising and marketing techniques to help invent the mythic Southwest, including today's concept of the ancient city of Santa Fe.

To get the job accomplished, the Harvey Company promoted as products such destination cities as Santa Fe and Albuquerque and the indigenous people of the pueblos along the nearby Río Grande. Through the Harveys' keen promotional skills, a lucrative market was created for turquoise and silver jewelry, pottery, and weaving. Today's thriving Native American arts and crafts market in the Southwest is largely a result of those early promotional efforts of the Harvey Company.

"We've gone from ritual to retail," was how an aging Native American craftsman put it many years later. At many of the Harvey properties, beginning in the early 1900s, Native American artists, including famed potters Maria and Julian Martinez of San Ildefonso Pueblo, were hired to create their wares before sightseers. Native artisans began to make objects especially for the tourist trade. Soon, many of these skilled artists were turning out lightweight jewelry, miniature pots and baskets, and other artifacts designed to suit folks anxious to tote home Indian souvenirs.

Such effective marketing schemes were tailor-made for Santa Fe, and the rejuvenated La Fonda provided an invaluable proving ground. Next, the Harvey Company instituted its famous Indian Detours, a sightseeing service based in the hotel. Cross-country railroad travelers could come to Santa Fe and jump into touring vehicles called Harvey Cars. They

visited Hispanic and Indian villages and other sites such as Puye, Mesa Verde, Taos, Bandelier National Monument, and Carlsbad Caverns.

"Rather like a major power acquiring a colony," wrote Paul Horgan in *The Centuries of Santa Fe*, "the Harvey Company entered Santa Fe to operate La Fonda in a sort of benevolent despotism as the social center of the country. Indians and tourism became big business in the twentieth century."

By 1927, the occupancy rate at La Fonda had skyrocketed. Management quickly selected southwestern architect John Gaw Meem—the epitome of versatility and creative energy—to conjure up expansion plans for La Fonda. Meem, a pioneer of the Santa Fe style, saw this architectural look soar in popularity in the 1910s and 1920s.

Of immense help to Meem was the talented Mary Elizabeth Jane Colter. This Kansas Citian was in charge of all interior design projects for the Harvey system, including El Tovar

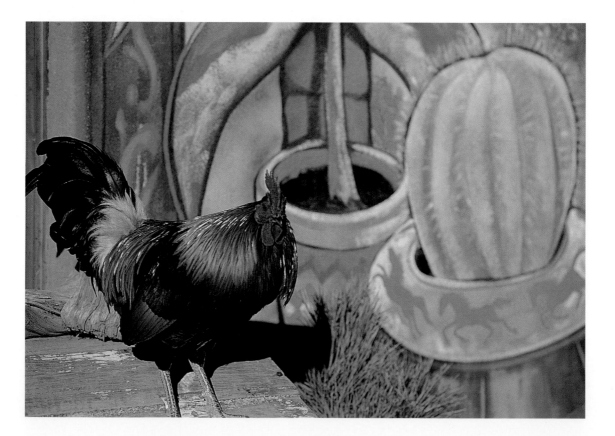

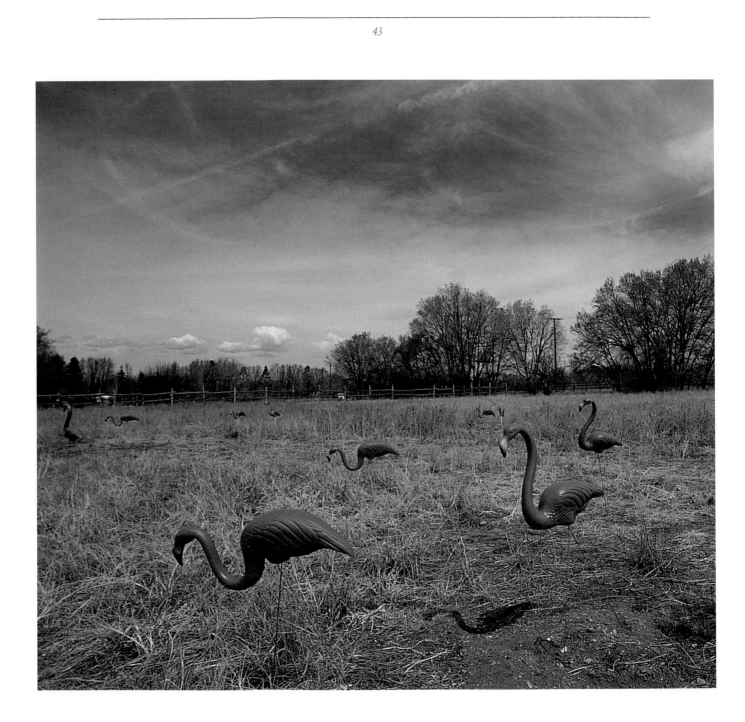

(Opposite) A rooster at the San Marcos Café on the Turquoise Trail.

(Top) A field of pink flamingos in Tesuque.

and other company properties on the rim of the Grand Canyon, El Ortiz in Lamy, New Mexico, and the Alvarado Hotel in Albuquerque.

By 1929, the creative team took the wraps off the ambitious La Fonda expansion project, including an entire new wing. The number of guest rooms was more than tripled. A fifth floor of deluxe suites, featuring fireplaces and private terraces, was added, along with an impressive open tower at the southwest corner. La Fonda now commanded the entire city block. Bright floral motifs by artist Olive Rush covered the walls of the new dining room and the patio. Colter also filled La Fonda with heavy antique chairs and tables, hand-carved cupboards, or *trasteros,* wrought-iron lamps shaped like yuccas, Native rugs and other textiles, tin and glass light fixtures, ashtray stands that looked like jackrabbits, and an array of Tarahumara and Pueblo pottery and Apache baskets.

The cuisine served by the energetic Harvey Girls in their long skirts appealed to the many travelers who came to see what they considered an exotic mountain city. At afternoon tea or during cocktail hour in the La Fonda cantina, all those who cared to eavesdrop could hear the murmur of foreign accents mixed in with lively conversations. The hotel drew numerous artists and writers. Endless flocks of tourists showed up, all anxious to attend the free nightly lectures about life in the region, presented in the grand hall, which came to be known as the Santa Fe Room.

There was dancing each evening except Sunday, when the orchestra played selected programs. Big bands led by such notables as Xavier Cugat, Paul Whiteman, and Lawrence Welk made sure their tour itineraries included a stop at the "Inn at the end of the Santa Fe Trail."

Forever a focal point for film stars on location and other celebrities, through the decades La Fonda played host to Salvador Dalí, Errol Flynn, Sinclair Lewis, John F. Kennedy, John Wayne, James Stewart, Robert Redford, John Travolta, Clint Eastwood, Shirley MacLaine, Zsa Zsa Gabor, Greer Garson, and others.

World War II journalist Ernie Pyle described La Fonda this way: "You could go there any time of day and see a few artists in the bar, or an Indian that some white woman loved, or a goateed nobleman from Austria, or a maharaja from India, or a New York broker, or an archaeologist, some local light in overalls and cowboy boots. You never met anybody except at La Fonda. You never took anybody to lunch anywhere else. I couldn't see how some of the struggling geniuses afforded it. I stayed at the De Vargas. Most of the artists seemed to be

A ceramic canteen by Christine McHorse is displayed at the Santa Fe Indian Market,
which attracts thousands of visitors each year.

genuine people, living normal lives, though there were freaks and pretenders—people who liked to dress up like Indians and stare into fireplaces. Many people who go to Santa Fe stay sane. Some go to pot."

Some things never change.

This impressive landmark that still passes for an old adobe castle is the hotel I came to love in the late 1960s, shortly after the Harvey Company had sold the property. The hotel's new owner, Corporación de la Fonda, promised to retain La Fonda's considerable charms. I cherish the hotel even now. I also accept it as a kind of faux-adobe Trojan horse that allows tourists to infiltrate the city, much to the chagrin of many local folks.

The fact is, Santa Fe has always been and will always be a commercial center. Tourists justify the opera, ski lodges, thousands of hotel rooms and hundreds of restaurants, art galleries, and jewelry stores in this city that now has nearly seventy thousand people. Barter and trade make the city function.

Yet another lesson I have learned is that Santa Fe will never stop changing. For some years, I played the game that many Santa Feans still like to play. I complained about all the alterations and expressed my desire for the old businesses on the Plaza to return. I recalled the Sombrero Bar, smelling of stale beer and the perspiration of working stiffs, Zook's Pharmacy, and the variety of everyday clothing stores and shops that catered to local citizens. I also thought about the Woolworth's store, famed for its Frito pies and an institution on the Plaza for sixty-two years, until it closed in 1997.

Then I remembered the old-timers and their lament when I first moved to Santa Fe. "You came too late," they told me. "You should have been here when I first came—Santa Fe was really something back then." I had to laugh. Here I was telling some fresh arrivals the same thing.

Woolworth's is gone, but the Palace of the Governors remains. I sit in the Plaza, shaded by blue pine and cottonwood, and watch the scores of Pueblo Indian vendors sitting beneath the long portal of the old building. These artisans come every day to take their places. They lay out blankets and cloths on the brick walkway and sell their jewelry, pottery, textiles, and other wares.

Near my perch on the Plaza, a young man and woman flirt with each other. I watch as a man crowned by a new cowboy hat snaps a photograph of the chiseled obelisk, and I notice some office workers eating lunch. I look up beyond the buildings and see the faultless sky and the hills turning into mountains. I know that by coming full circle, I am where I should be. I believe that I am sitting on the edge—the sill of heaven's window.

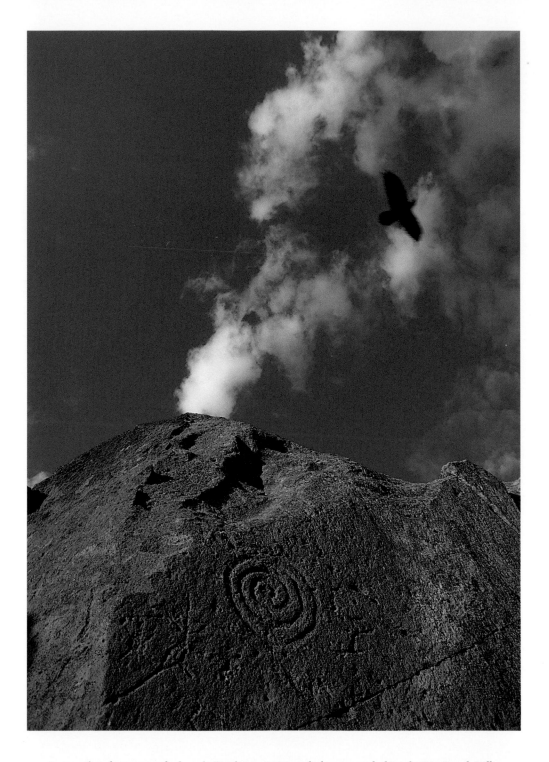

A raven flies above a petroglyph at the Tsankawi ruins on a high mesa overlooking the Río Grande Valley.

Visions of
Río Arriba

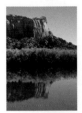

SOMETIMES WHEN I HAVE TROUBLE FALLING ASLEEP, I think of Los Luceros, the old land grant that is such a cornerstone in the history of northern New Mexico. In my mind, I see the broad stretch of land, cradled in a bend of the Río Grande, and the furrowed trunks and thick limbs of the cottonwoods standing guard. Considered a symbol of life by many New Mexicans, the trees are imposing specters against the deep blue sky. Eagles — satisfied after a meal of trout — preen in the highest boughs. I hear the laughter of ravens and the liquid whisper of heart-shaped leaves in the wind. I smell the fertile soil.

I see river otters at play, the old growing fields and pastures, groves of gnarled apple trees, and lilacs and gardens gone feral and then restored to full beauty. I see the Victorian cottage by the gate, the chapel with carved doors, and a guesthouse where so many illustrious authors and artists found comfort through the years. I see the old adobe structure that at one time served as a jail. And then before me stands the main house — Rancho de Los Luceros — filled with life and death, musty nightmares, moments of pure joy, and bittersweet memories. The architecture, the land, the layers of history at this place embody all that causes me to think of El Norte as heaven's window.

If my luck holds, when sleep finally comes, I turn to visions of the way things used to be long ago at Los Luceros. I go far back to the time when only Indian people dwelled along the river. They cultivated crops, created vessels from the earth, found game and fish in the mountains and streams, and practiced their religion and rituals. Then I find myself in the early

A bulto of St. Francis in Estaca, New Mexico.

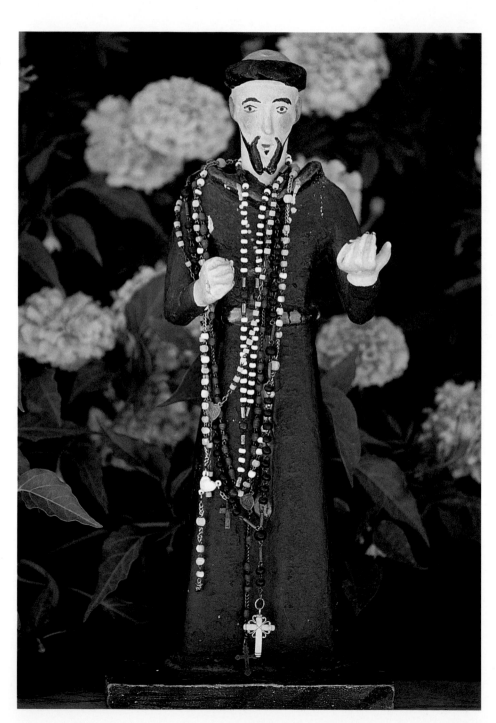

1700s, long after the Spanish came. I recall that Native workers drafted from the nearby pueblo dug the Acequia Madre, the Mother Ditch, which still delivers water to this land and quenches the thirst of meadows and orchards from Velarde to San Juan. Before me passes a long procession of all the people who have lived here—Pueblo, Spanish, Mexican, Anglo, and mixed-blood descendants. I watch the shifts and changes as fire, flood, pestilence, and the constant flow and ebb of nature and humanity sweep over the land.

Located eight miles north of Española and close to the farming community of Alcalde, the historic ranch complex of Los Luceros remains the most intact nineteenth-century rancho in all of northern New Mexico. But of even more importance, human occupation of what came to be called Los Luceros may date back at least two centuries before the Spanish arrived, to A.D. 1350, if not earlier. This special place, where the Native American, Spanish, and Anglo cultures have left their prints, remains relatively unknown.

Archaeological work in the late 1900s supported the conclusion of historians and others that the rancho sat near the ruins of a large settlement of tribal people. This village was most likely a seasonal fishing and farming camp associated with the ancestral Tewa pueblo of Pfioge.

People have dwelled here since before the Río Grande, which once ran very close to the site of the rancho, shifted its course to the west. Long before outsiders came to this land, the Pueblo people enjoyed a settled way of life based on agriculture and the rhythms of nature. Descendants of the Anasazi and other ancient tribal peoples, they were tied in blood and spirit to the ancient Southwest master builders who created homes in stone cliffs and along canyon walls, such as the ruins that still exist at Bandelier National Monument. These people tended terraced gardens, engineered roads, and studied the heavens. They used smooth rock walls as their canvas and created baskets from the valley's grasses. Then they suddenly and mysteriously disappeared.

In time, the Spanish came. By 1598, Don Juan de Oñate founded the first Spanish colony in New Mexico, only five miles south of Los Luceros, at the confluence of the Río Grande and the Chama Rivers. The expeditionary force was comprised of armored soldiers bearing crossbows, harquebuses, and rapiers; Franciscan priests, "knights of Christ," eager to save pagan souls; and colonists, including many mestizo (Spanish-Indian) families. A true son of the New World, Oñate was born not in Spain but in New Spain, or Mexico, to a prosperous family that controlled silver mines near Zacatecas. The young nobleman gained even more

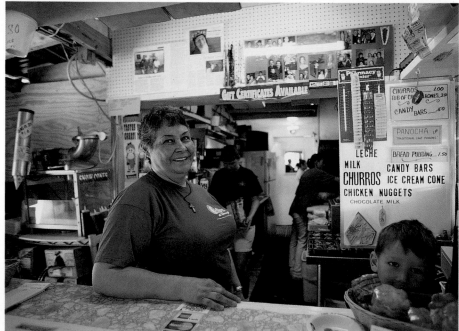

riches by wedding a wealthy mestizo woman who was supposedly a descendant of Aztec Emperor Montezuma and Hernán Cortés, the Spanish conqueror of Mexico.

After years of pursuing a military career and prospecting for silver, Oñate—hungry for more fame and fortune—jumped at the opportunity to lead the Spanish Crown's colonizing venture into northern New Mexico. Astride a prancing charger, Oñate, with his intrepid entourage, blazed a two-thousand-mile route—now known as El Camino Real, or the Royal Road—from deep in Mexico to a distant and unknown land. The expedition paused at the present site of El Paso, Texas, and then continued northward into the upper Río Grande valley, traversing some of the landscape that conquistador Francisco Vásquez de Coronado had explored decades earlier. The Oñate party brought along stores of food, iron tools, medicine, weapons, seeds, shrubs, and thousands of cattle, horses, sheep, and goats.

The travelers stopped briefly at several Indian settlements, including the largest pueblo in New Mexico, which Oñate called Santo Domingo, because the colonists arrived on a Sunday. After persuading the pueblo leaders to gather in a kiva and to reluctantly render their allegiance to Philip II of Spain and the Pope and then kneel and kiss the ring of a friar, Oñate and his band pushed on.

Just north of Santo Domingo, where the Río Grande enters one of many long, impassable canyons on this stretch, the Spaniards detoured and scaled La Bajada. From that point— at the summit of the cliff of black basalt—the Oñate party continued into the Río Arriba country to the north.

By July 1598, they had reached the Tewa-speaking village of Pfioge on the east bank of the Río Grande, near what became Los Luceros many years later. Oñate and the colonists immediately took control of the pueblo. All the inhabitants swore loyalty to the Spanish Crown. As royal vassals, they served as a labor force and provided their conquerors with food and other necessities. The camp was renamed San Juan de los Caballeros, or Saint John of the Warrior Knights, in honor of John the Baptist and in tribute to the Spanish newcomers.

Within a short time, swarms of rodents and insects appeared in the overcrowded village, and conditions became increasingly uncomfortable. Oñate decided to move. The colony

(Opposite, clockwise from top) Roger Hubert and Travis Law (in mirror) at Los Luceros.
Leona Tiede with her grandson at Leona's Restaurante in Chimayo. "El Goyo,"
biker and Vietnam vet from Chimayo.

still eager for revenge, plundered and burned houses and made prisoners of hundreds of men, women, and children. Then they escorted the subdued Acoma defenders to Santo Domingo pueblo for trial. The resulting punishment was severe for all of the culprits, including twenty-four men older than twenty-five whom Oñate ordered "to have one foot cut off and to do twenty years of personal servitude." The other unfortunate captives avoided mutilation but ended up condemned to years of slavery and service to their Spanish overlords.

Meanwhile, back in the Río Arriba, the fledgling capital of San Gabriel was struggling despite the infusion of fresh settlers to stimulate growth and replace disgruntled colonists who deserted to New Spain. Harsh winter storms, mutinies against Oñate's leadership, and severe food shortages took a heavy toll.

After several grueling years and a barrage of complaints from colonists, Oñate fell out of favor. By 1607, he had resigned the governorship of New Mexico, and royal authorities recalled him to Mexico to stand trial. He was absolved of some crimes, but his convictions on a variety of other charges stemmed mostly from his mismanagement of the colony and abuse of Pueblo people. Stripped of all titles and heavily fined, Oñate relocated to Spain.

At the time of Oñate's death, in 1624, the original New Mexico colony of San Gabriel was long gone from the banks of the Río Grande. By 1609 or even earlier, Don Pedro de Peralta, the new royal governor, had moved most of the colonists south from the concentration of Tewa pueblos. Peralta and his followers settled at Santa Fe, strategically situated at the southern end of the Sangre de Cristo Mountains, and it became the capital of the province.

Some of the original Spanish colonists, however, did not move to Santa Fe but remained in the San Gabriel area and the Río Arriba. Archaeological evidence suggests that throughout most of the 1600s, today's Los Luceros was the site of many subsistence farms for raising various crops and livestock. It is known that Juan de Dios Lucero de Godoy, eldest son of Captain Pedro Lucero de Godoy—a stalwart soldier who had come to New Mexico with Oñate—petitioned for title to thirty-one thousand acres of the land. But before Lucero de Godoy could claim the land grant, he and thousands of fellow colonists fled the territory.

In August 1680, Popé, a San Juan religious leader living at Taos, galvanized the northern Pueblo Indians in a rebellion against the Spanish. Weary of years of religious and economic oppression, the Native people of the countryside exploded into a bloody revolt. Most of the northern settlers and Franciscans in the outlying areas were massacred. Some of the Spaniards and mestizos in the Río Arriba escaped to Santa Fe and the shelter of the Palace of the

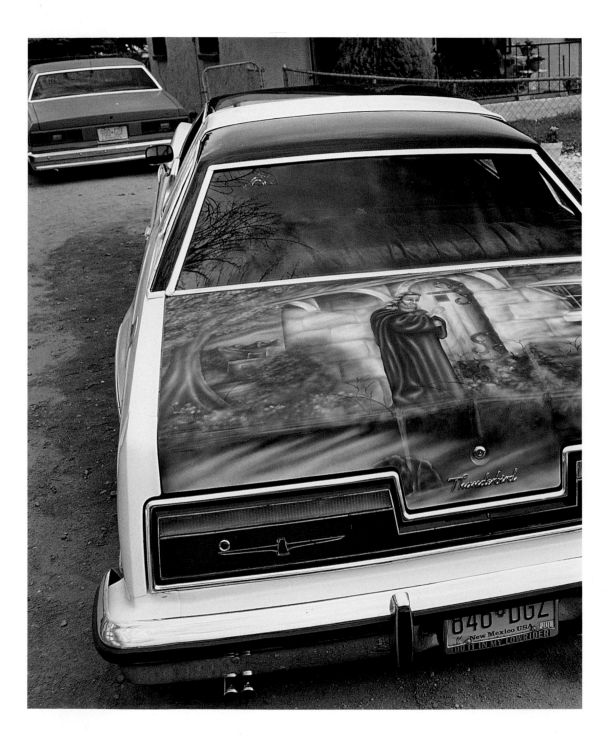

This 1974 Ford Thunderbird low rider is owned by Flavio and Concha Armijo;

the painting is by the Chimayo artist Randy Martinez.

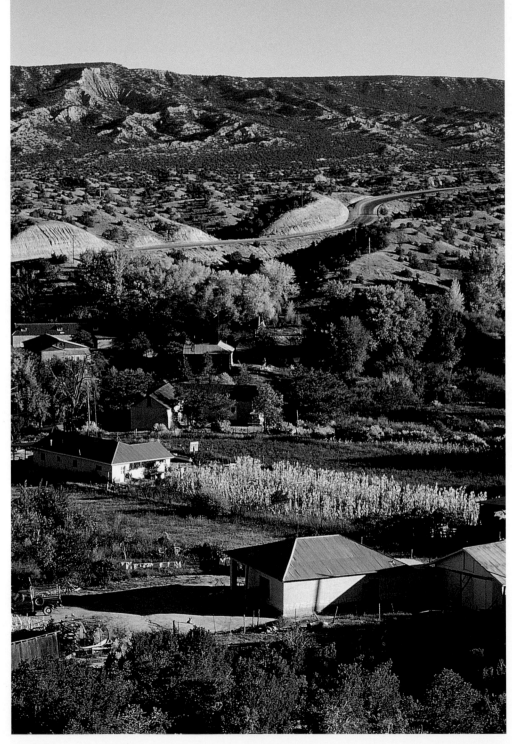

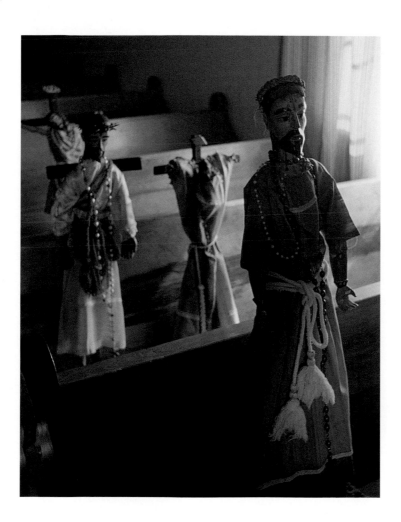

Saints wait to be photographed at the church of San Antonio de Padua in Cordova.

Governors, but the angry Pueblo people stormed the capital city. The survivors retreated southward, along with Spanish refugees from the Río Abajo, to El Paso.

For the next twelve years, the colony ceased to exist, and the old San Gabriel settlement and nearby ranchos bordering the Río Grande remained abandoned. That changed in 1692, when the newly appointed governor and captain-general of New Mexico, Don Diego de Vargas Zapata y Luján Ponce de Léon y Contreras, led his army from El Paso along the Río Grande to Santa Fe.

A nobleman with two decades of experience as a warrior in New Spain, Don Diego de Vargas was determined to retake the province from Indian insurgents. He quickly found as he pushed northward that most of the Pueblo Indian alliance had collapsed. A so-called peaceful reconquest by Vargas became part of a popular myth that exists to this day.

In actual fact, Vargas and his Spanish soldiers met resistance at several Pueblo sites. They met open combat, and staged full-scale assaults on Indian-occupied Santa Fe and at Santa Clara, Cochiti, and Jemez pueblos. In the four years he spent crushing the Pueblo rebels, Vargas ordered the public executions of scores of captives and sentenced hundreds more to long terms as slaves. Spanish military forces encountered determined opposition until 1696.

At the same time, many of the colonists who had fled the province a dozen years before returned to rebuild places for themselves on the northern frontier. One of those was Juan de Dios Lucero de Godoy. He was unable to prove the land grant at Los Luceros, and so he established a home with his family south of Santa Fe, where he lived until Indians killed him, in 1703. That year, the earliest written record of settlement on the Los Luceros property appeared in a land grant made to Captain Sebastián Martín Serrano, a strong political leader and another veteran of the Vargas force that took back the province from the Pueblo people.

Captain Martín, as his friends and associates called him, and his wife, María Luján — whose family had been massacred at Taos during the 1680 Pueblo Revolt — returned north from Santa Fe in 1698 to settle in the fertile river bottom at Los Luceros.

In 1712, Martín formally petitioned the governor for control of the fifty-thousand-acre land grant. This action followed the death of Felipe Antonio Sisneros, a joint owner of the property with the Martín brothers and the victim of an Apache attack. Martín bought out his partner's widow and allowed the family to continue to reside on the land.

In the 1712 petition, Martín also declared that he and his five brothers had resided on the land since 1703 "not withstanding the great risks to be encountered from the Apache enemy, who occasionally make their descents upon us." According to Martín, he and his brothers gave the Indians at San Juan Pueblo a parcel of valley land in exchange for their help in digging the first acequia on the east side of the Río Grande.

The wide acequia that still serves Los Luceros is known as "Sebastián Martín's ditch." I think of the old Spaniard when I stop at the ditch to splash cold water on my face. On the irrigated plowed property, Martín planted hundreds of apple trees, a large cornfield, and a garden of chile and onions. On the rest of the land, he grazed cattle, horses, and sheep.

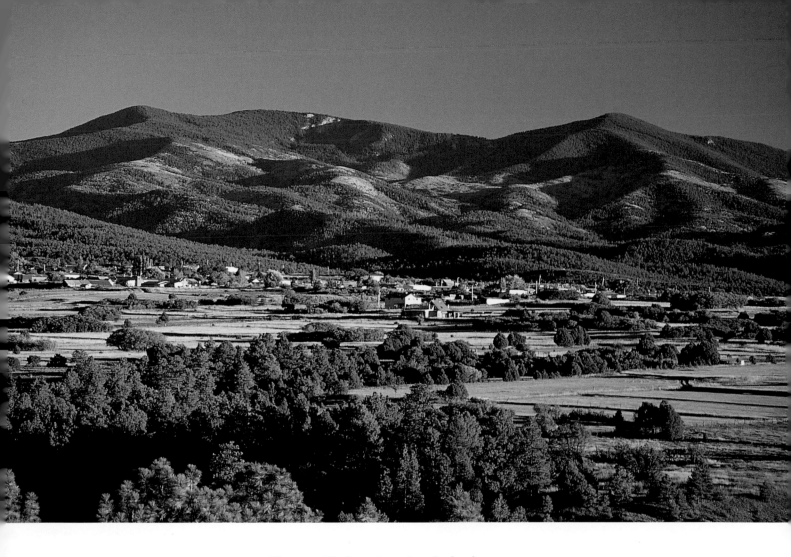

The town of Truchas, a former Spanish colonial outpost,
was built on top of an eight-thousand-foot mesa.

The sprawling grant extended for five miles upriver, from San Juan Pueblo on the south to Picuris Pueblo on the north. It also stretched for eighteen miles, from the Black Mesa of lava to the forested peaks of the Sangre de Cristos on the east. Martín later gave part of the land close to the mountains to the village of Las Trampas, site of San José de Gracia, a magnificent adobe church dating to the late 1700s. The old church and the nearby *canoa,* or flume, carrying precious water across a deep arroyo make Las Trampas a favorite stop on a winding two-lane state highway popularly known as the High Road to Taos.

Despite difficulties and dangers such as the constant threat of Plains Indian attacks, epidemics, drought, floods, and other acts of God and man, Martín and his family prized the

The views from Truchas are spectacular, with Truchas Peak to the east and the Río Grande Valley to the west.
Truchas remains one of the most culturally traditional of the northern New Mexico Hispanic villages.

land grant north of San Juan. He named the settlement Puesto de Nuestra Señora de la Soledad del Río del Norte Arriba—Outpost of Our Lady of Solitude of the Upper River of the North. Most of the frontier settlers called it La Soledad—a fitting title for this lonely retreat.

Captain Martín wisely built an adobe house with a pair of round towers, or *torreones*, to defend against any bands of Comanches or Apaches assailing frontier ranchos. During the years, as Martín and his wife raised ten children, several of whom they survived, the house increased from four rooms to twenty-four, along with a stable and storage area, all under one

flat mud roof supported by huge vigas. Besides all the family members, the house also accommodated animals and at least twenty-one household servants, mostly Navajo, Ute, Apache, and Comanche people.

Today, the massive adobe walls of the main Los Luceros house, carefully restored and fortified beginning in 2000, no doubt contain some of the lower floor of the original dwelling. It had grown quite large by the time of Martín's death, in 1763, at age ninety-two.

The frontier outpost of forty-four families totaled 364 people in 1750, according to a census report. In 1772, the division of La Soledad among Martín's heirs was under way. Within a few more years, maps sometimes referred to the settlement as Río Arriba.

In the late 1700s, as various heirs bought and sold their shares of the property, Barbara Padilla, a granddaughter of Captain Martín and his wife, wed Santiago Lucero. He was a descendant of the illustrious Lucero de Godoy family that had helped to colonize New Mexico and unsuccessfully laid claim to the land grant long controlled by the Martín family. La Soledad soon became Los Luceros, meaning both "the Lucero folks," and "morning stars."

Julián Lucero, nephew of Santiago and Barbara, systematically bought parcels of the ranch from the many Martín and Lucero descendants. By 1827, only six years after Mexico had secured its independence from Spain and New Mexico had become part of the Mexican nation, Julián had bought out his siblings and all other heirs to Los Luceros, including the orchard and much of the outlying property. The enterprising landowner also took a wife, Barbara Antonia Sisneros, a granddaughter of Antonio Sisneros, the original partner of the Sebastián Martín land grant many years earlier.

Long the center of social and political activity in the region, Los Luceros became the Prefectura del Norte in 1844, making the rancho one of three major divisions of the Departamento de Nuevo Mexico. That quickly changed in 1846, when the twenty-five years of Mexican rule came to an end during the Mexican War. General Stephen Watts Kearny and his Army of the West conquered New Mexico and raised the United States flag over the Palace of the Governors in Santa Fe. During his time in northern New Mexico, Kearny paid a call to Los Luceros and slept behind the thick adobe walls of the rancho.

Los Luceros survived the occupation of gringo troops and the abortive rebellion of 1847, when revolutionists from Taos attempted to overthrow the new American government.

As the citizens of the Río Arriba adjusted to the acquisition of New Mexico by the United States and the influx of outsiders, more change came to Los Luceros. In 1851, Julián

Lucero presented the main house and orchard to his daughter, María Marta, who the year before had married Elias T. Clark, an Irish-born trader from Missouri. For the next decade the Clarks continued to enlarge their landholdings while Clark ranched and farmed and operated a general-merchandise store in the nearby village of Alcalde.

In 1851, Clark became clerk of the U. S. District Court for the Second Judicial District of the Territory of New Mexico. Two years later, the council of the legislative assembly in Santa Fe selected him as its secretary. With his interest in judicial affairs obviously increasing, Clark also acted as Río Arriba County judge. For several years, Los Luceros served as the county seat and the ranch house as county courthouse. Throughout the 1850s, Clark held court in the upstairs *sala*, or parlor. He converted another building into a jail. A sturdy black locust tree with an obliging limb provided a gallows for criminals sentenced to capital punishment.

The Clarks, like all those who ever lived in the main house, added their own architectural touches. During that period, Los Luceros—one of the grand residences of northern New Mexico—earned its reputation for graciousness and hospitality. In 1855, W. W. H. Davis, U.S. attorney for the Territory of New Mexico, who later became acting governor, wrote in glowing terms of his visit to Los Luceros:

> We continued up the valley until nearly dark, when we arrived at the hospitable ranch of Mr. Clark, at Los Luceros, where we stopped for the night. He welcomed us with genuine hospitality. We were ushered into the *sala*, where we found a cheerful fire blazing upon the hearth, which put new life into our benumbed bodies. For me the ride was unusually fatiguing, and when I dismounted it was with difficulty that I could walk into the house. For the first time I had backed a Mexican saddle, which, though pleasant to ride upon when you have become accustomed to them, generally punish the uninitiated for a few days. I thought to myself that, if thus crippled in the first day's ride, there would be nothing of me left long before the circuit should be completed. In a little while supper was announced, when we were seated at a well-filled board, presided over by Mrs. Clark in person, contrary to the general custom of Mexican ladies, who do not eat with their guests. Soon after, the *colchones* [mattresses] were spread upon the floor, when we retired, and slept soundly until morning.

In 1860, Elias Clark, the *patrón* of Los Luceros, died of consumption at age forty-five. His brother, Louis Clark, took over the dry goods store at Alcalde. In 1876, a disgruntled customer who was denied credit at the store shot and killed Louis. By then, the Los Luceros property had passed to Eliza Clark, the only child of Elias and María Marta Lucero Clark. Only nine years old at the time of her father's death, Eliza married a young farmer named Luis M. Ortiz when she was barely fifteen.

With assistance from a Navajo family, Eliza tended to visitors and the needs of her four children. Luis oversaw the rancho and became the sheriff of Río Arriba County, dispensing justice at Los Luceros. The couple also continued to update the property, including the addition of a Territorial-style veranda encircling the second story of the main house.

According to local legend, the Ortiz family built a private chapel on the grounds near their home to show gratitude after the house survived a flood in 1886. They named it La Capilla de la Familia Santa, "The Chapel of the Holy Family," and erected it near the site of an original chapel dating all the way back to the era of Sebastian Martín. Eliza and Luis Ortiz donated the building to the Archdiocese of Santa Fe in 1891. The Ortizes lie buried beneath the altar.

After the turn of the twentieth century, the Ortiz family abandoned Los Luceros. Left unattended, the big house slowly deteriorated as rains seeped through the roof and soaked the adobe walls. Flooding from the acequia did more damage, and vandals broke windows and stripped away much of the woodwork. It appeared that the end was at hand for one of New Mexico's most historic sites. Even when statehood finally came to the Territory of New Mexico in 1912, there was nothing much to cheer about at Los Luceros.

Then in the early 1920s, a woman from a prominent Boston family came to the rescue of the sagging property on the Río Grande. Mary Cabot Wheelwright, a statuesque arts patron and a collector looking for a bit of adventure, purchased Los Luceros.

Wheelwright was forty years old when she arrived in New Mexico, in 1918. She first lived in Santa Fe and then settled near Alcalde at the San Gabriel Ranch, not far from Los Luceros. It was a dude ranch operated by Richard and Carol Pfaffle, who once owned other properties, including Ghost Ranch near Abiquiu. The San Gabriel offered a convenient base for Wheelwright's explorations of the great Southwest. She explored the Río Arriba region and far beyond on horseback, usually accompanied by Jack Lambert, a cowboy guide. Eventually, her scouting trips took her to the Navajo Reservation.

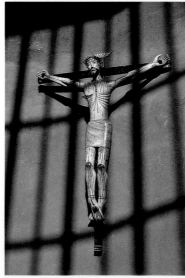

(Top) Running along the Chama River canyon, the road from Abiquiu to Christ in the Desert Monastery can be treacherous in the winter or after a rain.
(Bottom) Christ in the Desert Monastery, an isolated retreat run by Benedictine monks, contains bultos and other religious artifacts.

(Opposite) Kitchen Mesa is reflected in a pool at Ghost Ranch, a Presbyterian study center west of Abiquiu. Georgia O'Keeffe spent time at the ranch painting the nearby canyons and striking rock formations.

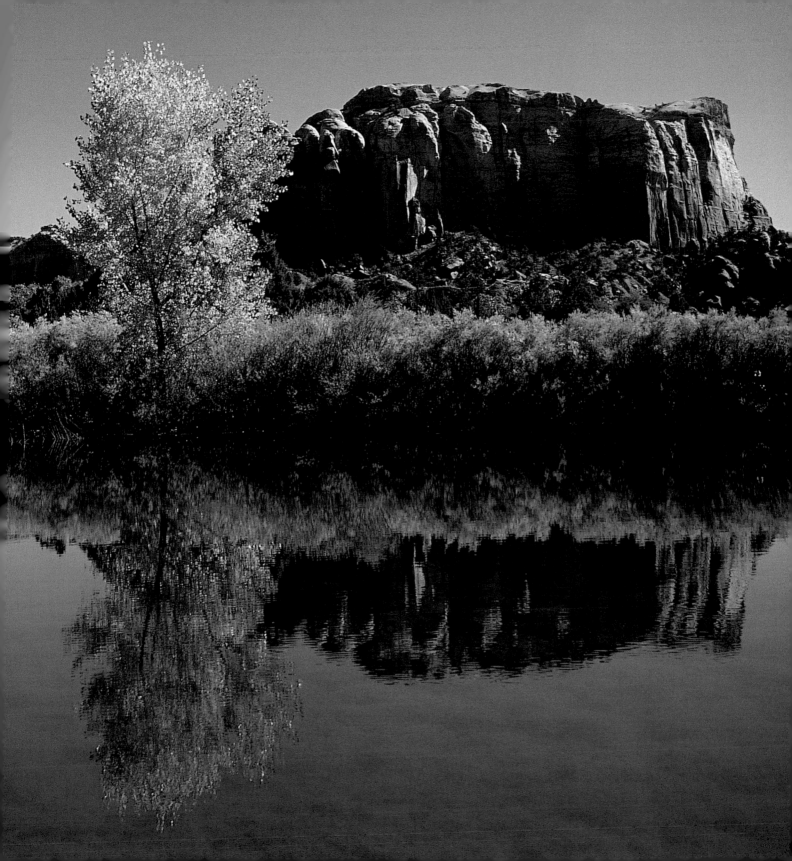

At a remote trading post, Wheelwright met Hastiin Klah, a Navajo singer and respected medicine man dedicated to preserving his Native religion by weaving depictions of ceremonial sandpainting figures. Fascinated with Klah's weavings and the Navajo culture, Wheelwright bought one of his rugs after vowing never to walk on it. He became her teacher and often visited the Río Arriba. Wheelwright and Klah remained fast friends and collaborators for the rest of their lives.

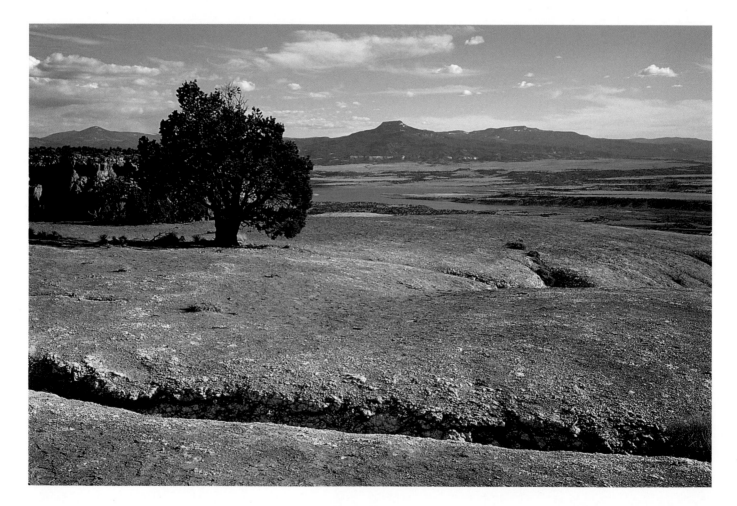

The view from the top of Kitchen Mesa at Ghost Ranch
looking toward Pedernal Mountain in the far distance.

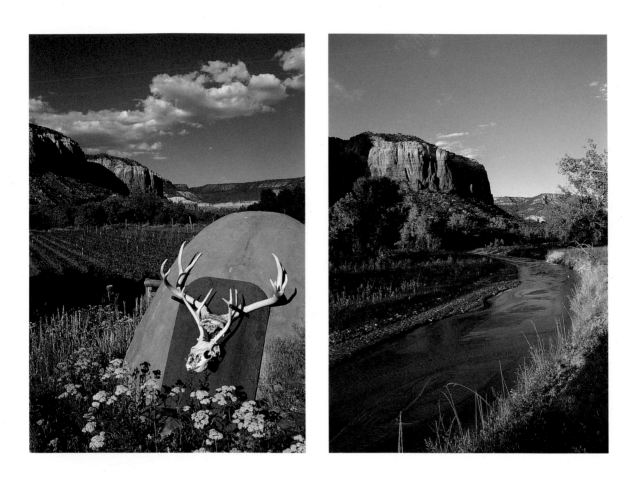

(Left) At Elizabeth Berry's ranch above Abiquiu, she grows specialty crops like chile to supply many of Santa Fe's restaurants. (Right) A tributary of the Chama River runs southwest of Abiquiu.

In 1923, Wheelwright shifted her home base from San Gabriel to the nearby historic property that would become her home until her death, in 1958. She resurrected an old but popular name for her new home—Los Luceros. The name has remained to this day.

With plenty of expert local help, Wheelwright restored the crumbling adobe walls. She remodeled some of the main house, in particular the doors and windows, in the Spanish Colonial–Pueblo Revival style that was coming into vogue at the time. Despite those changes, much of the ranch house, including the two-level gallery and interior woodwork, retained the architectural integrity from the territorial period of the late nineteenth century.

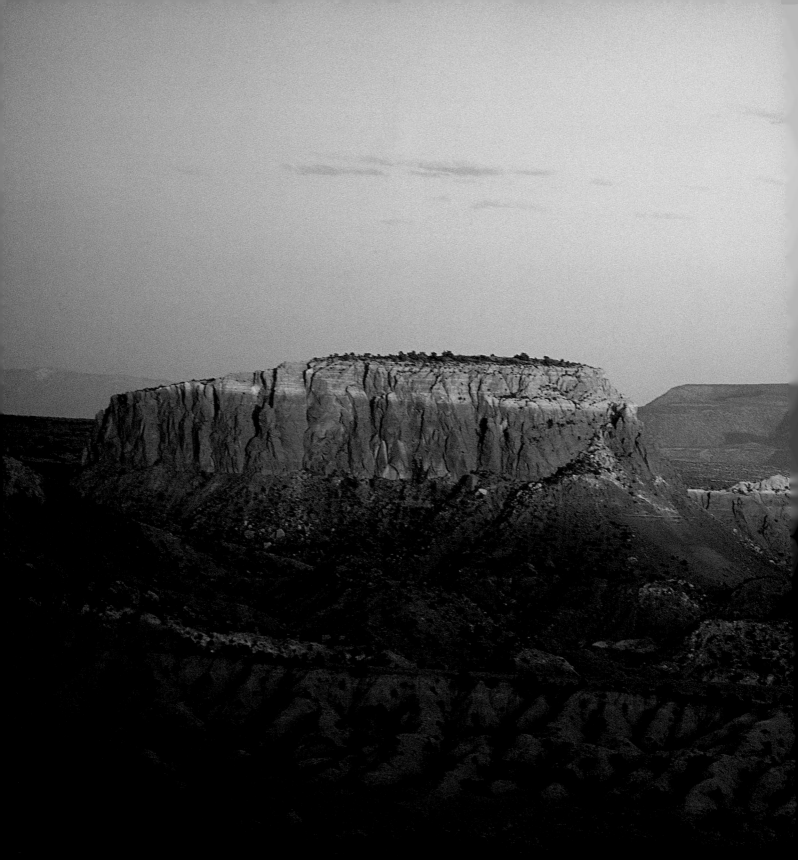

The light turns
the landscape to gold on a mesa
at the magic hour in Abiquiu.

Besides caring for the collection of neglected buildings, Wheelwright tended to the growing fields, orchards, and gardens. In the yard surrounding the main house, she planted lilacs, a New Mexico favorite ever since the blooming shrubs had arrived with merchants journeying down the Santa Fe Trail. Wheelwright also acquired historic plants, including English roses and hollyhocks, from the decorative garden laid out in the 1800s at the architectural treasure El Zaguán, on Canyon Road in Santa Fe. Peony bushes imported from China in the nineteenth century still flourish in the twenty-first century at Los Luceros.

Wheelwright faced a deluge of visitors at her New Mexico ranch retreat. To accommodate everyone and to provide a degree of privacy, Wheelwright converted the 1900 L-shaped adobe foreman's residence into a comfortable guesthouse. During the many years Wheelwright resided at Los Luceros, a flow of artists, expatriates, and avant-garde thinkers stayed at the ranch. Some of the guests included D. H. Lawrence, Mabel Dodge Luhan, Aldous Huxley, William Penhallow Henderson, Carl Jung, Mary Austin, Elsie Clews Parsons, Willa Cather, and Oliver La Farge.

Roberto Alire, an El Rito artist, carved this cross from a standing tree on his property.

Even after she adopted Abiquiu as her summer residence, Georgia O'Keeffe frequently stayed at Los Luceros and sometimes helped in the kitchen. Maria Chabot, who roamed the countryside with O'Keeffe and also conceived the Santa Fe Indian Market in the 1930s, lived at Los Luceros and often oversaw daily operations. Laura Gilpin — one of the foremost photographers of the Southwest — lugged her cameras from Santa Fe and created striking images of ranch scenes and portraits of the two-story main house.

For many years, while living at Los Luceros, Mary Cabot Wheelwright continued to work closely with Hastiin Klah toward their shared goal of creating a safe haven to preserve Navajo culture, religion, and legend. They fulfilled that dream in 1937 when Wheelwright founded the Museum of Navajo Ceremonial Art, today called the Wheelwright Museum, in Santa Fe. Designed in the octagon shape of a giant traditional hogan, the research center has a collection that includes the Klah sandpainting textiles as well as hundreds of reproductions of ancient ceremonial art.

Wheelwright bequeathed the Los Luceros ranch house to the museum. She left the rest of the property to her friend Maria Chabot. Subsequently, the museum declined the bequest, and the big adobe house reverted to Chabot. When it became clear to Chabot that she could not maintain the extensive holdings, she asked Georgia O'Keeffe if she knew of any potential buyers. O'Keeffe immediately called Charles Collier, who many years before had guided the famous artist to her Abiquiu home.

In the early 1960s, Charles Collier and his wife, Nina, purchased Los Luceros. In addition to the historic buildings and 120 acres of property, the acquisition included some of the Spanish colonial art left by Wheelwright. Much of the collection proved important to the Colliers, such as *Our Lady of Guadalupe*, a striking painted panel executed by an anonymous artist in the late eighteenth or early nineteenth century. Such artifacts and objects of art, combined with the new owners' extensive collection of paintings, religious statuary, and carvings, became the nucleus of the International Institute of Iberian Colonial Art, directed by the Colliers.

Born in New York in 1909, Charles Collier was the son of John Collier — sociologist and writer, champion of self-determination for Indians, and commissioner of the Bureau of Indian Affairs under President Franklin Roosevelt. A reformer and crusader for social rights, John Collier came with his wife, Lucy, to Taos in 1920 at the urging of persuasive patron of the arts Mabel Dodge Luhan. Accompanying the Colliers were their three sons — Charles,

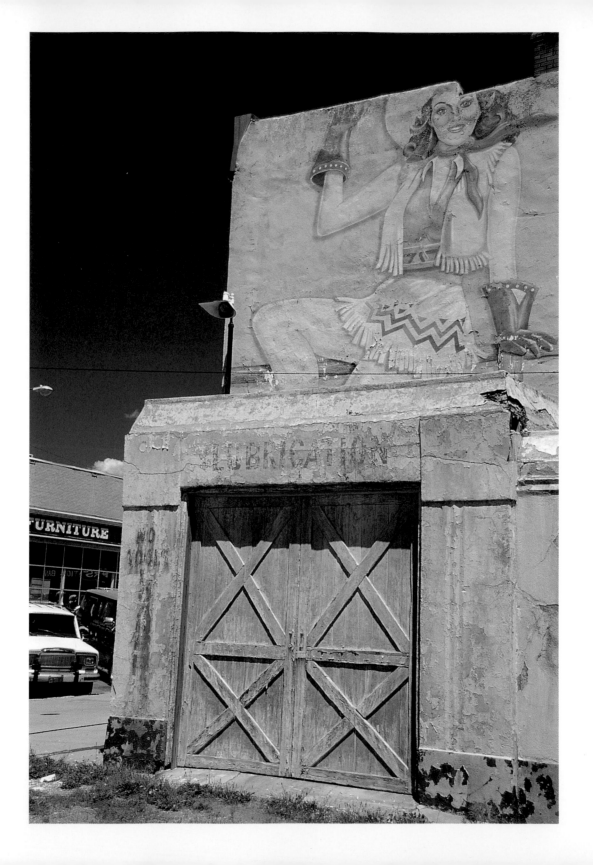

(Opposite) A wall in Las Vegas still boasts a faded mural. Las Vegas prospered with the arrival of the railroad in 1879 and today retains a variety of architectural styles.

(Top) La Iglesia de Cristo Rey was built in 1887 in El Llano outside of Las Vegas. The mural was later added in 1972. (Bottom) The pickup and matching wall belong to Katherine Duke, Las Vegas.

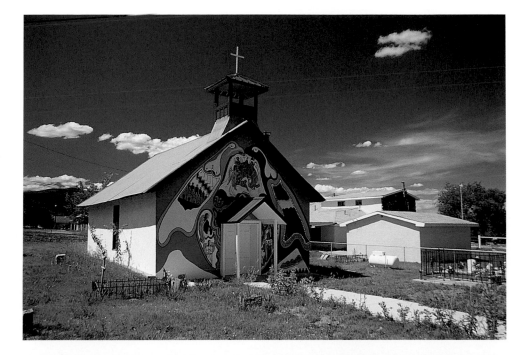

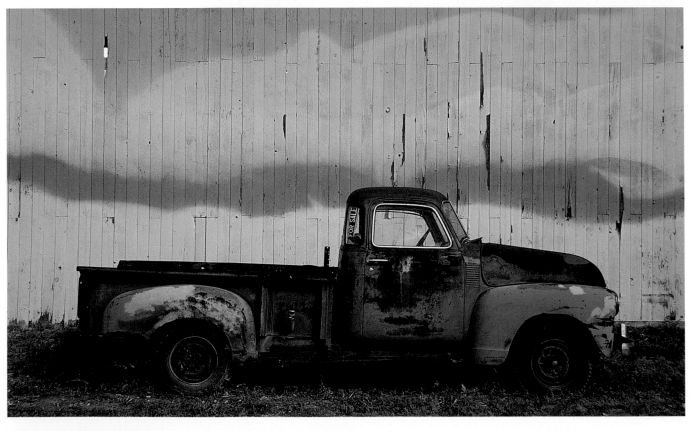

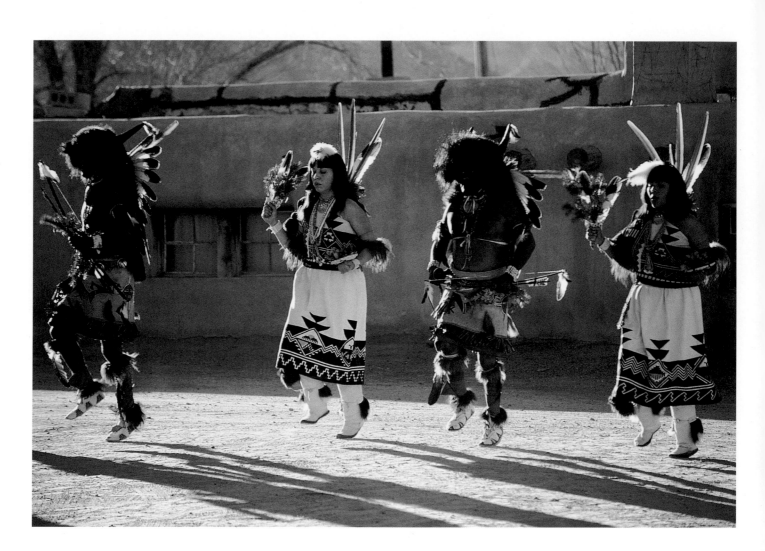

Buffalo dancers perform at San Ildefonso Pueblo.

their eldest; Donald, who became a prominent anthropologist; and John Jr., who became a documentary photographer.

That stay in Taos had a profound and lasting effect on John Collier and consequently on his entire family. Inspired in part by watching tribal dances at Taos Pueblo and talking to people like Tony Luhan —Mabel Dodge Luhan's Indian husband —Collier became an activist for Indian causes and civil rights. He was convinced that the Pueblo culture provided a fitting

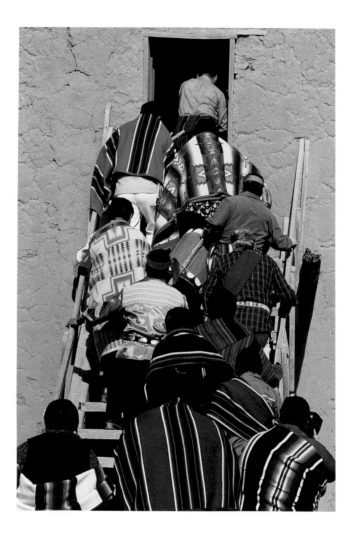

Drummers wearing their Pendleton blankets take a break
during the dances at San Ildefonso Pueblo.

model for the rest of the nation to follow because it did not focus on the material aspects of life.

Collier devoted his energy to preserving Indian culture and securing key reforms in the management of tribal affairs. He gallantly battled for liberalization of government policy and successfully defeated the Bursum Bill—proposed federal legislation that would have taken

tens of thousands of acres of New Mexico lands guaranteed by treaty away from the Pueblos and halted their land and water rights without adequate compensation. Vilified in some circles, the soft-spoken Collier remained highly regarded by most Indian tribes, especially during the New Deal years when he pushed the Indian Reorganization Act through Congress. This landmark legislation authorized tribal self-rule under federal supervision, put a halt to land allotment, and generally promoted measures to enhance the tribes and encourage education.

Throughout the 1920s, Collier's son Charles often escorted him as he made the rounds of pueblos and villages. The young man watched as his father climbed a ladder at Taos Pueblo and entered a chamber where council members waited, wrapped in the white sheets they wore during summer months. Charles Collier saw Tony Luhan rise and heard him speak, his voice trembling with rare emotion. The boy went with his father to Santo Domingo and San Juan and to the other pueblos far to the west. They sat in rooms packed with people. The air was thick with smoke from cigarettes fashioned from dried cornhusks and twists of tobacco. They ate lunches of stew, fry bread, and watermelon. They went to Los Luceros to visit Mary Cabot Wheelwright and her many guests. Charles Collier never forgot those times with his father and those moments spent at the old rancho on the Río Grande.

And then, years later, Charles owned Los Luceros. During the 1960s, the Colliers did what they could to restore Los Luceros, despite great expenses and limited funds. They launched an extensive stabilization of the main house and constructed reinforced concrete foundations to prevent further settling. They made improvements on the chapel, by then called La Capilla de Nuestra Señora de Guadalupe. In 1964, the Colliers installed handsome double doors that came from a house in Peñasco, the handiwork of Gregorio Ortega, a skilled nineteenth-century craftsman from the village of Truchas.

When the Colliers' sons and daughters grew up, they went off on their own. Some lived far away. A few stayed near the ranch and often returned to visit their parents. Charles, who many years before had been instrumental in starting the Soil Conservation Service for the federal government, not only cared for the buildings of Los Luceros but also the precious earth. He hired local folks to look after the fields and orchards and maintain the acequia. Together, Charles and Nina Collier acquired more pieces of Spanish Colonial art and placed them throughout the big house, filling the *sala* and the bedrooms and parlors.

✥

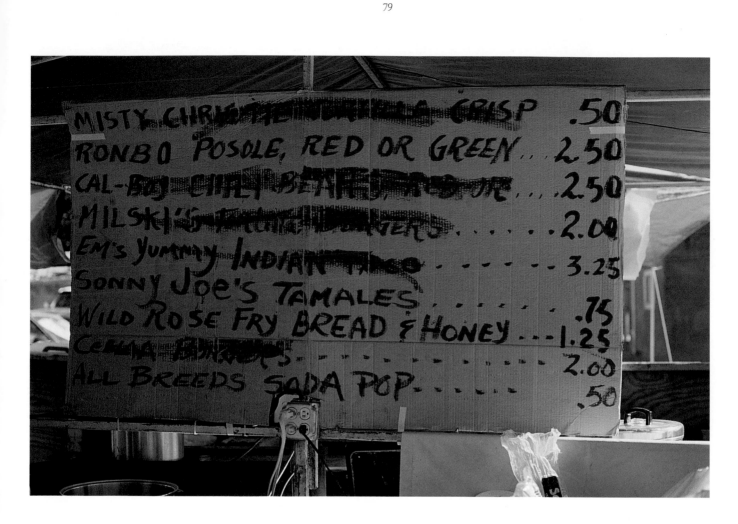

Menu at the Eight Northern Pueblos fair.

In 1970, I met the Colliers and visited Los Luceros for the first time. I enjoyed my time in a place that had witnessed so much of the past. I roamed the land and pictured the Indian people who had walked there so long before me. Every room in the comfortable casita, or guesthouse, where I stayed—even the kitchen and bath—had a fireplace. The shelves were crammed with books, many of them first editions signed by the authors. I spent my mornings eating tart apples from the orchard and reading D. H. Lawrence, Paul Horgan, and Willa Cather. The large front window offered a stunning view of fertile fields and everlasting trees and the distant hills and mountains.

*These ruins at Bandelier
National Monument
were home to the
Ancestral Puebloans
during the twelfth
century.*

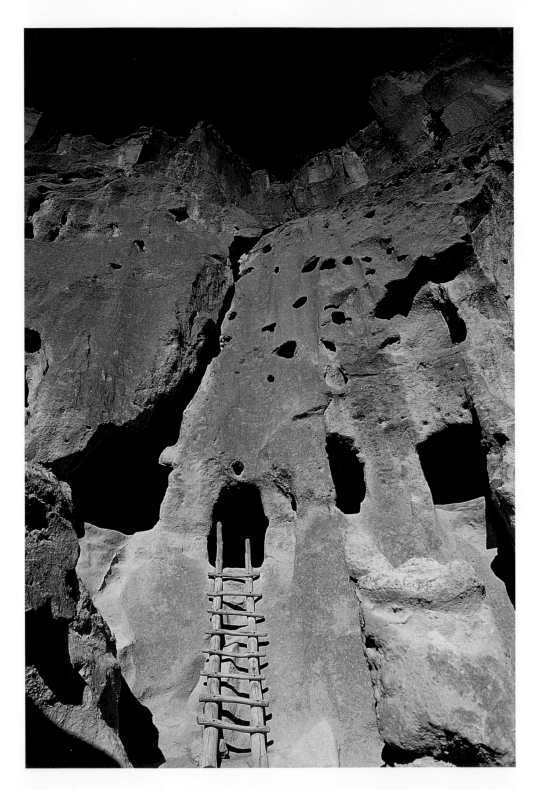

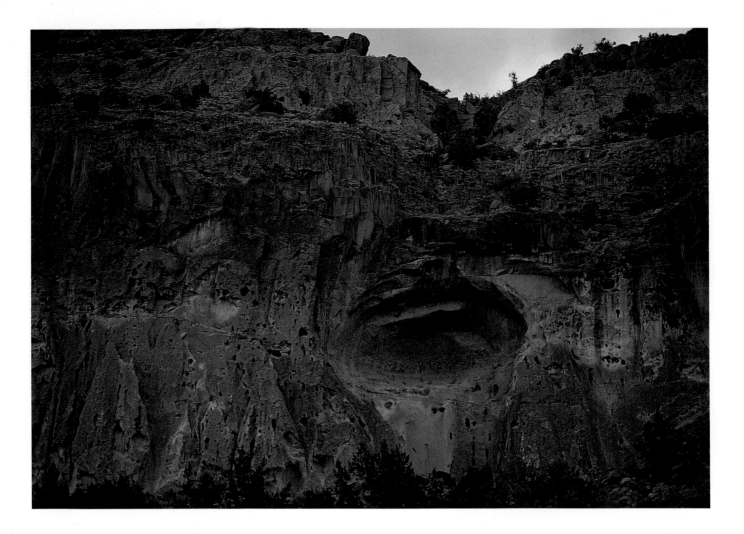

Painted Cave, with its striking wall paintings, is part of
Bandelier National Monument.

Afternoon visits at the main house over cake and hot tea with Nina Collier became an indulgence to anticipate. A lover of art, music, and gardens, she reminded me of Eleanor Roosevelt. Most of the time, she sat at a long table in the dining room, her hands continually busy with sewing and stitching. She said in a matter-of-fact way that she was making her shroud.

Nina Collier was also the first person to tell me about the ghosts. She said spirits resided at Los Luceros and sometimes made their presence known to the living. Nina often saw the image of a woman long dead move through the rooms in her rustling skirts and lace veil and sometimes appear on the shadowy staircase. She said she saw the ghost kneeling in prayer in

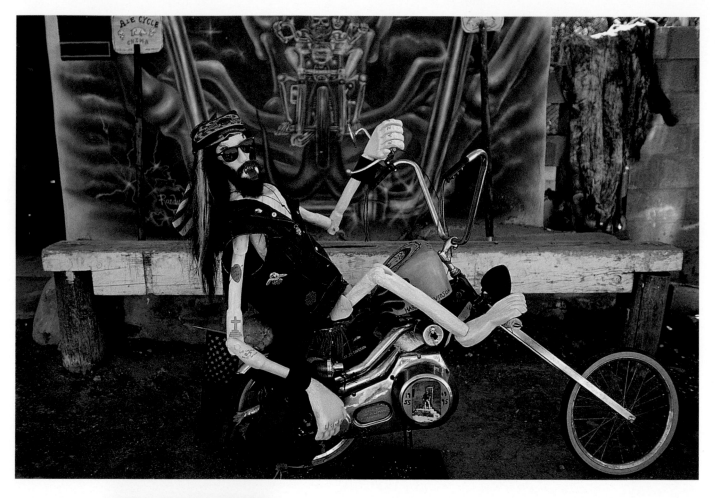

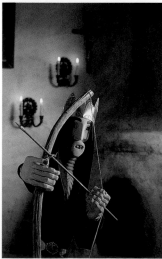

(Top) Nicholas Herrera, the noted El Rito artist,
created this piece in memory of his friend Armando
Trujillo, who owned this Chimayo motorcycle shop.
(Bottom) Another of Nicholas Herrera's carvings, a
muerta, *is ready to take aim at those fated to die.*

(Opposite) The Penitente Brotherhood holds services in a
morada, *or meeting house, in the Mora Valley.*

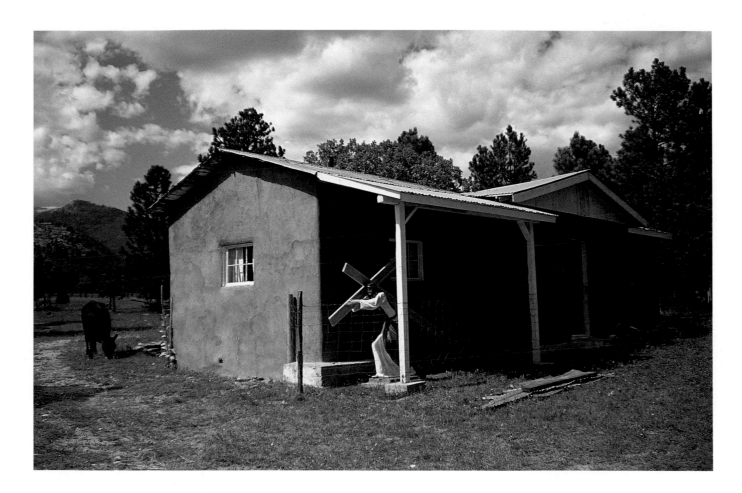

the chapel, and that her soft sobs were sad and pitiful and tore at Nina's heart. Without ever saying so, Nina insinuated that she and the spirit communicated with each other.

In later years, I met others who knew of the spirits at Los Luceros. Some of them told me that when they stayed in the main house, they saw the ghost of María Marta Lucero, the woman who had inherited the ranch in 1851 and married Elias Clark, the Missouri trader. A few believed Elias had murdered María and that accounted for the uneasy spirit, a theory never proved. Still others believe the spirit of Elias Clark haunts the old ranch. They point to Judge Clark's sentencing of culprits to die on the end of a rope dangling from the black locust that stood near the big house. From his second-floor office next to the sala, Clark could see the jail and had a clear view of the hanging tree. Legend has it that Clark still paces there,

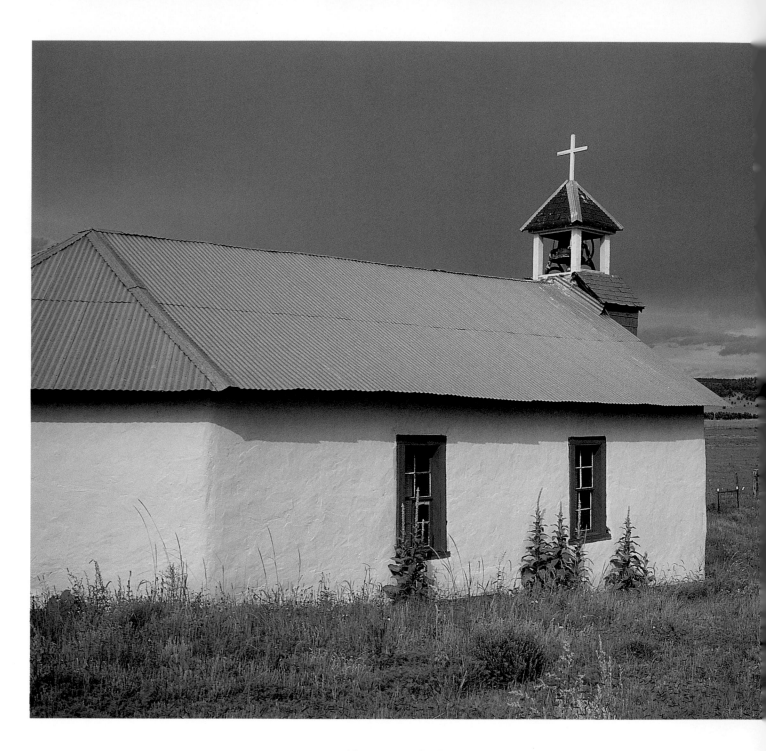

*Santa Teresa del Niño Jesus Church in
El Turquillo, near Mora.*

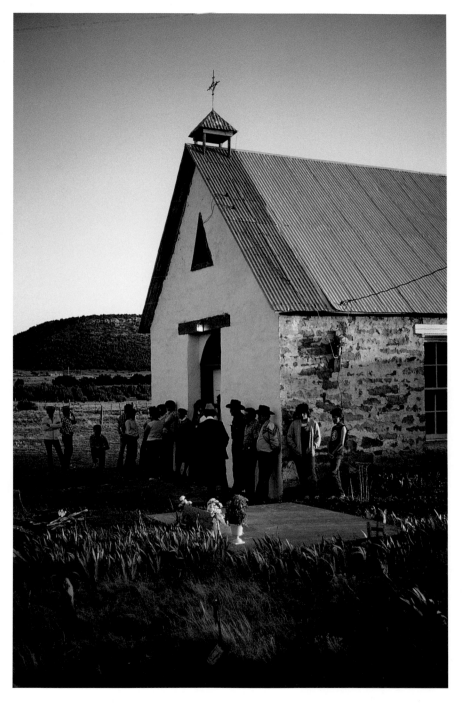

Churchgoers at Gonzales Ranch

on a summer evening.

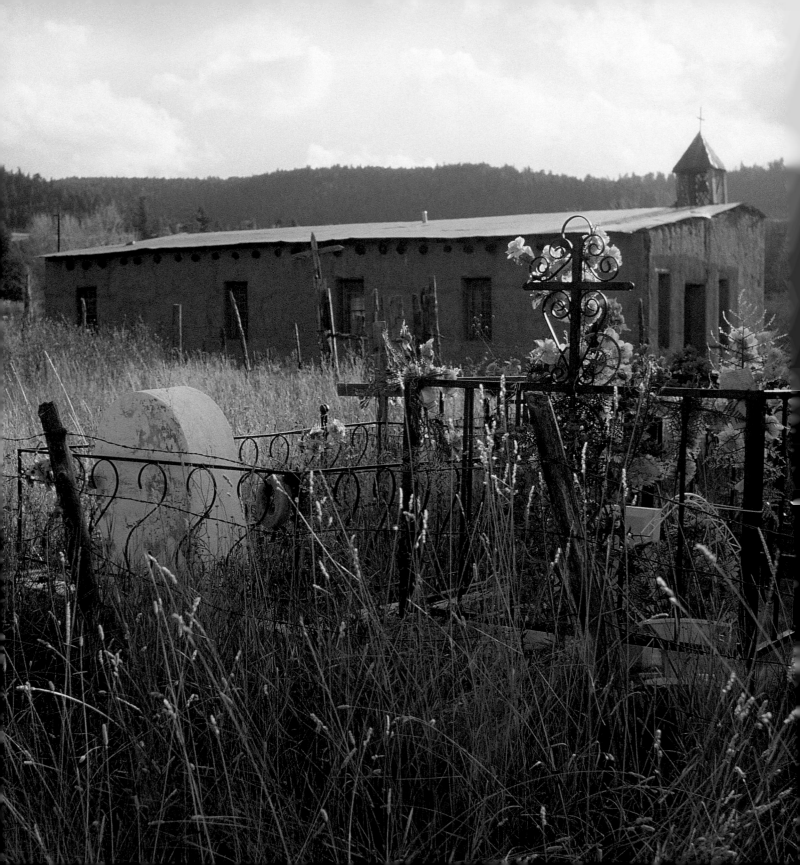

(Opposite) San Acacio church at Llano Largo about two miles from Peñasco.

(Top) Horses relax on a porch near Canjilon.
(Bottom) Bullriding at the Wagon Mound rodeo.

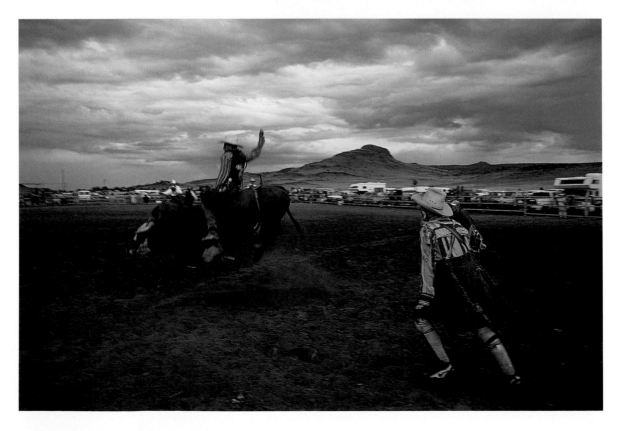

contemplating the fates of the condemned, and that is why the painted floor appears worn to this day. Maybe a few of the spirits are criminals whose lives ended in the yard.

I never directly encountered any spirits at Los Luceros, although I did feel a shaft of frigid cold in a downstairs room and had the hairs on my neck raised a few times. I also met a psychic there who claimed she had made contact with a force beyond the physical world.

The Colliers' time at Los Luceros ended all too soon. Nina died in 1973. Charles left the ranch some years later due to strained finances and passed away in Santa Fe in 1987. Nina was laid to rest in her shroud, buried near the chapel where it is said the restless spirit still prays. Sometimes when I return to Los Luceros, I stop at Nina's grave. I pull weeds and read the poem by Rabindranath Tagore inscribed on her gravestone:

> Your smile was the
> Flowers of your own fields,
> Your talk the rustle of
> Your own mountain pines,
> Your heart was the woman
> That we all know.

I suppose I knew that as soon as the Colliers were gone, along with their vast inventory of Spanish Colonial art, more change was in store for Los Luceros. The Collier family was not financially able to keep the ranch. Once again, the ranch fell on hard times. In the next twenty years, a parade of owners and caretakers took over the property. They ranged from banks and land developers with dreams of turning the historic lands into a housing subdivision to nonprofit organizations with good intentions but not much capital for upkeep and badly needed improvements. Tourism officials looked over the property, and there was talk from local politicians about turning the ranch into a state park.

One owner, a man from southern California who thought about using Los Luceros as a summer camp for underprivileged children, left his mark on the land. He had wood carvers gouge humanlike spirit faces in the trunks of some of the ancient cottonwoods. Thankfully, he left before they could deface every tree on the place.

Through the years, I watched as buyers came and went. Word would get around that someone else had picked up the property, and then before long, I would hear that Los Luceros

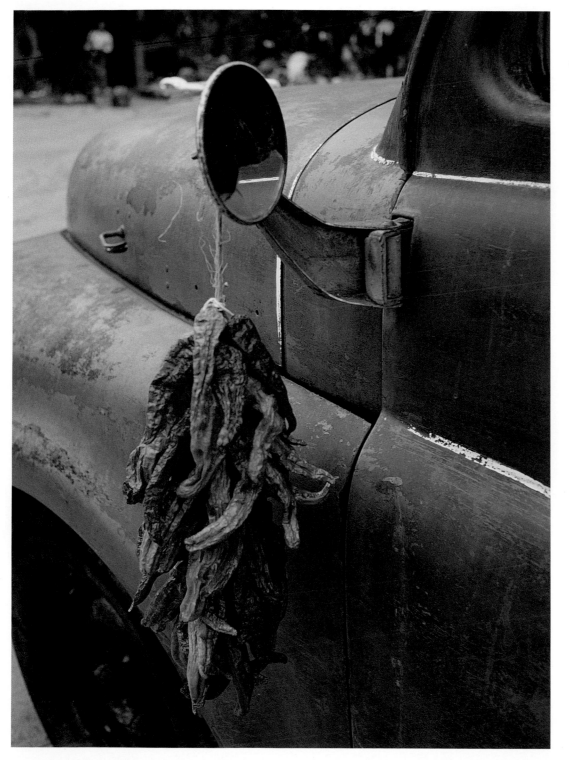

An old pickup with a chile ristra *in Alcalde.*

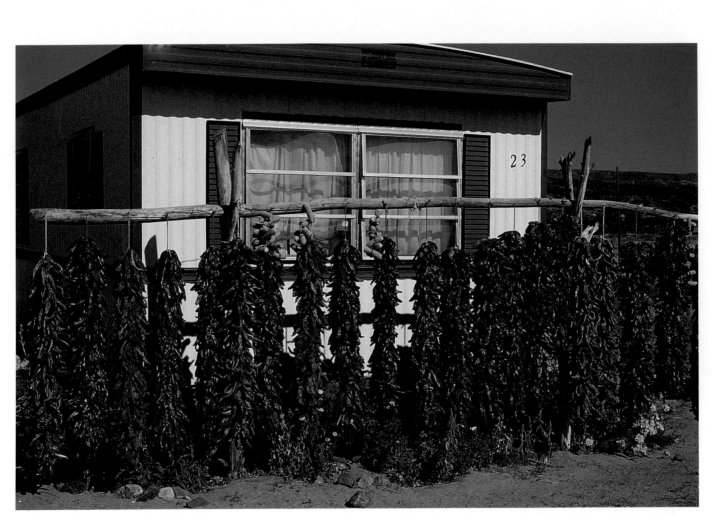

Chile ristras *are on display outside of Española. Northern New Mexico*
produces some of the best chile in the state.

was back on the market. I always thought the ranch would make an ideal location for an artists' colony or a center where people could gather to share ideas, argue issues, and lead creative and productive lives. Thankfully, I was not alone. Others with passion and resources wanted to bring the property back to life.

Roger Hubert—a self-effacing New Mexico cowboy with deep roots in the Río Arriba—stepped forward. With the grit of a broncobuster, Hubert was determined to rescue Los Luceros.

(Top) Nancy Youngblood Lugo, noted Santa Clara potter, carves one of her bowls. (Bottom) Margaret Tafoya, the famous potter and grandmother of Nancy Youngblood Lugo, sits outside her house in Santa Clara.

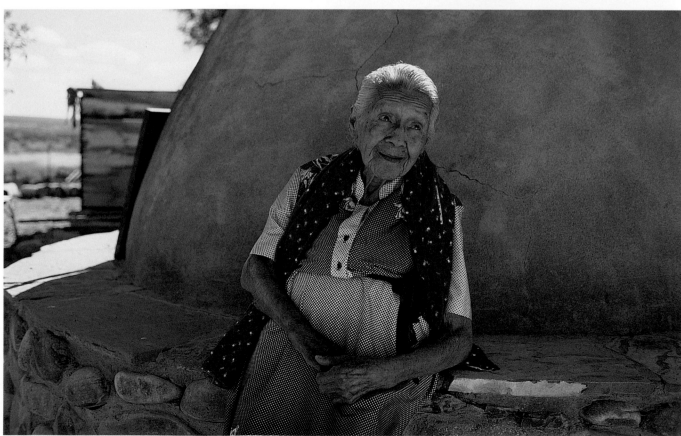

After watching the property for a long time, Hubert hooked up in the late 1990s with a Dutch outfit that he believed had good intentions for Los Luceros. The company from Holland wanted to develop some of the property for homesites but also wanted to restore the main ranch house and the surrounding buildings. Others from the area disagreed, including Lucy Collier, one of Charles and Nina's daughters. Lucy worried that any development might endanger a fragile part of northern New Mexico history. Yet like Hubert, she wanted to see the big house restored and eventually opened to the public.

While Río Arriba County officials and local citizens debated the pros and cons, Hubert rolled up his sleeves and quietly went to work. Vowing to defend the old place with his life, he became the guardian of Los Luceros and moved into the main house with his bedroll. He told me that he would never forget the first night he spent there.

"I was all alone, and I laid out my sleeping bag on the floor and listened to the owls and the wind," said Hubert. "I was cold to the bone and it was so dark and musty, but then I started talking to the house. I said, 'Okay, I am here now and I will protect this place. I will save it.' I actually spoke to the house and to the spirits, and I even sang some. I felt honored to be there."

Within a few minutes, the frigid house began to warm up. Soon, it was as if every room had a roaring fire. Hubert knew then that he was in exactly the right place. He was home.

After that, he placed a radio in an upstairs room and played classical music continuously so any trespassers would think people lived there. Hubert and some local boys, including a few whom he suspected of having defaced the property in the past, went to work to spruce up the place. The ditch needed cleaning, orchards needed pruning, and there was plenty of brush to cut and trash to haul away.

When Río Arriba County finally rejected the Dutch firm's proposal to subdivide and develop the land, Hubert did not miss a beat. He kept right on working, convinced that others would come along and help rebuild history at Los Luceros — adobe brick by adobe brick. He was right.

In 1998, Frank and Anne Cabot, New Yorkers and distant relatives of Mary Cabot Wheelwright, purchased Los Luceros with the intent of completely restoring the historic buildings to their previous glory and turning the ranch complex into a living history museum. Thanks to their efforts, Los Luceros is still the finest representation of a composite of architectural styles and building techniques in New Mexico. Inspired by those who came before

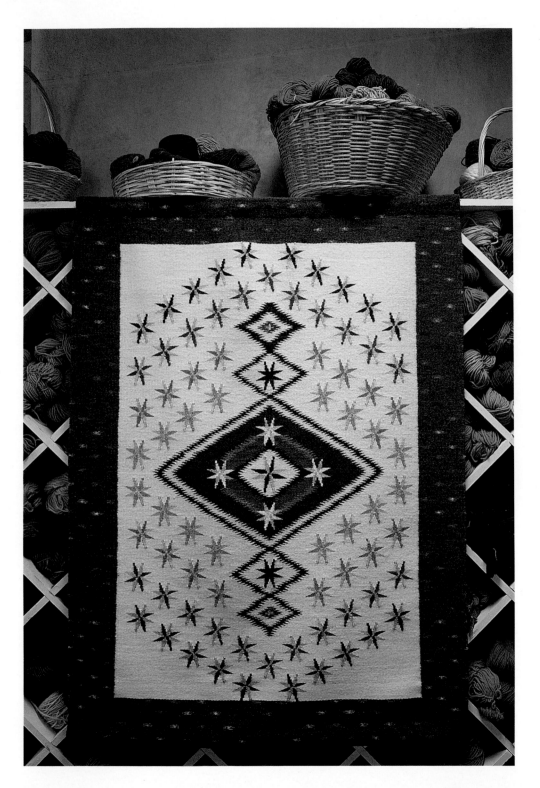

A weaving by Teresa Archuleta Sagel.

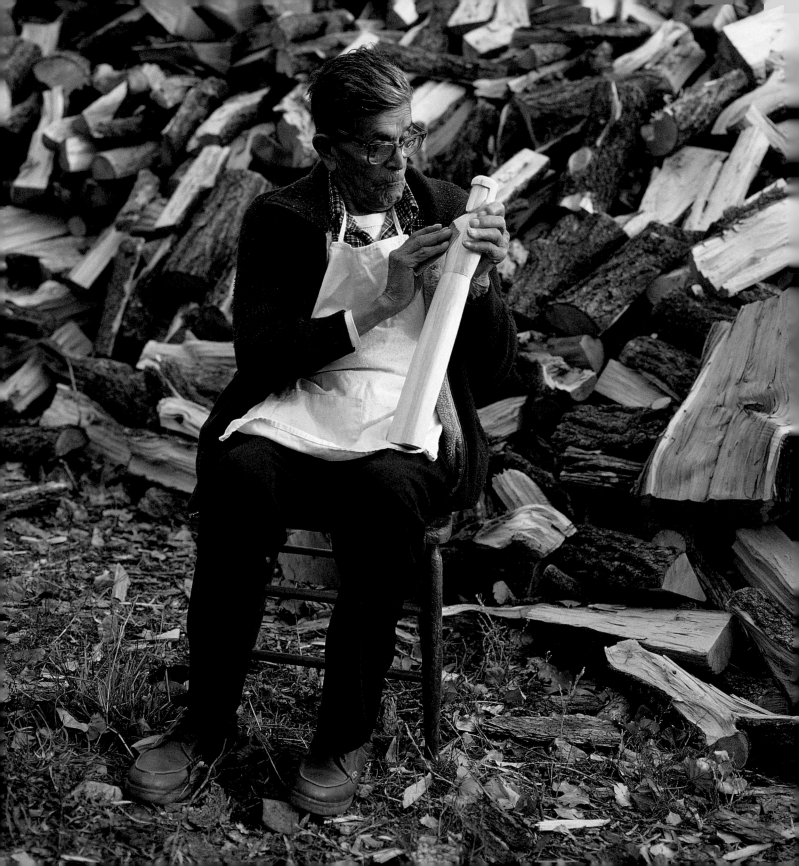

them, the Cabots formed Los Luceros Foundation, hired architects and engineers, and brought in top experts in historic preservation.

Now you know why, when I have trouble falling asleep, I think of Los Luceros—a quintessential story of northern New Mexico and the Río Arriba. And if I do dream of the old place, then I dream the sweetest dreams of all. I awake feeling fresh and whole.

Likewise, when I drive out from Santa Fe and visit the rancho, I am hopeful. This was true even in the sad past, when I found the architecture fractured and abused and the land mistreated and neglected. At Los Luceros, I experience renewal. I stalk the dimensions of this enduring place and I am at peace.

Sometimes the song of a coyote—that trickster and seducer that roamed this land before anyone—echoes through the twilight as a fitting benediction.

(Opposite) George Lopez of Cordova carves one of his many santos.

Native grasses of northern New Mexico.

*H*eaded
for Taos

*W*HEN I GO TO TAOS, I HAVE OPTIONS. If I am not in a hurry, I take the High Road to Taos, with its looping switchbacks and long picturesque approaches as the road winds through a necklace of villages, most of them settled on the Spanish frontier in the mid-1700s. When time matters or if I want to pretend I am a traveler on El Camino Real, I opt for another scenic route. I go to Taos by way of the highway that enters the twisting canyon of the Río Grande just past the fruit stands of Velarde. In due course, the road rises out of the steep canyon, and there before me is Taos Mountain, suddenly looming in the distance.

When I use the river road going north, I face still more options. Driving out of Santa Fe, I race across the border of Río Arriba County—a sprawling area the size of Connecticut that stretches all the way to the Colorado line. At the highway town of Española, a fairly good-sized farming community and shipping point, I have my pick of several strip-mall cafes that put to shame some of the fancy Santa Fe eateries.

Sometimes I pull into Blake's Lotta Burger. I dine on a cheeseburger smothered in green chili and watch the traffic pass in review. Blake's, especially on weekends, is an ideal spot to witness the low riders cruising north and south.

A term used in the Hispanic West since World War II, "low rider" describes both a vehicle that has been customized and lowered to only inches from the ground and the person who is driving it. Low riders and the low-riding phenomenon have spread throughout the

The pickup is northern New Mexico's preferred means of transportation.

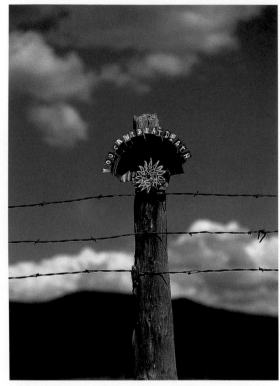

A reminder of our mortality is found on a Taos fence post.

Southwest. Like many others, I firmly believe the most dedicated low riders—men, women, and children—abide in northern New Mexico. I also acknowledge that Española is the self-proclaimed capital of the low-rider community.

The main difficulty low riders have in Española is when police stop them—not for speeding, but for going too slow. They rumble by in flawless cars with gleaming metal and chrome. They parade for hours, listening to their tunes, with their motto, "Low and slow," ever on their minds.

Low riders tell me it is all about pride. They prove it every time they go out on a ritualistic cruise. Group cruising—often called "slow prancing"—is a family activity for some and an acceptable method of courting for others. Maybe that is why sociologists compare low riding to an old Hispanic custom—men and women strolling around the plaza, always in opposite directions, to check out the crowd. Watching the shiny cars glide before me, I cannot help but agree. An advertisement that the local chamber of commerce once placed in a national

magazine pops into my mind. The ad depicted a low rider with the message, "I've visited the Eiffel Tower and seen the Taj Mahal by moonlight, but it wasn't until I came to Española that I saw a '55 Chevy doing a mating dance."

Rolling north again through Española on Highway 68—the Taos Highway—I spy the flashy casino that makes money for San Juan Pueblo, and I know the river canyon is dead ahead. Then as I pass the Don Juan de Oñate Visitor & Cultural Center, I recall that some folks from Acoma Pueblo paid a visit here in 1998 to mark the four-hundredth anniversary of the arrival of the Spanish in New Mexico. The Acomas brought no flowers or tributes. Instead, they sliced off the right foot of the heroic bronze statue of Oñate astride his horse. In claiming responsibility for the deed, the "Indian commando group," as the Acomas called themselves, described the attack as symbolic retaliation for the conquistadores' order to amputate the right feet of two dozen young Acoma warriors defeated by the Spanish in an uprising.

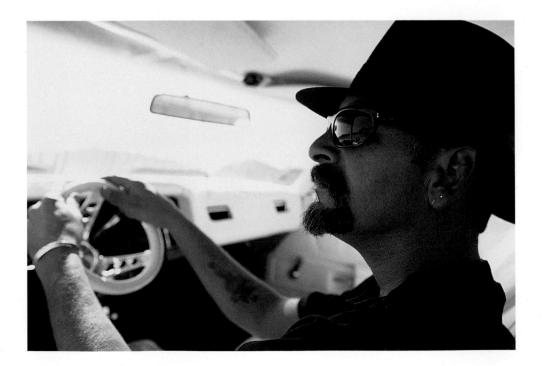

Atanacio "Tiny" Romero enjoys his '75 Chevy
Caprice low rider.

The visitors' center replaced the statue's missing foot, but the controversy over Oñate did not go away. Grudges, especially those involving cruel and unusual punishment, last a long time in New Mexico. Debates over whether Oñate was a courageous trailblazer or a ruthless conqueror will never end. Richard McCord, a thoughtful Santa Fe journalist and one of my first editors, said in his column: "Perhaps Oñate's bronze foot should be left off, and a plaque installed to explain its absence. Then pilgrims to his shrine can absorb his grandeur and his horror, in some form of truth."

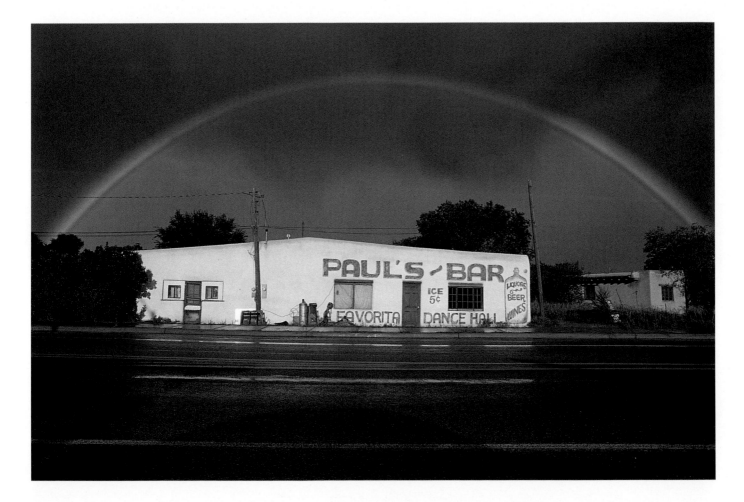

Paul's Bar in Taos.

Mindful that all too often the victors write history, I usually feel no urge to visit the monumental Oñate statue. Instead, if I want to make another stop before continuing to Taos, I watch for the side roads leading to Alcalde and Los Luceros and the scattered homes, farms, and orchards feeding from the mother ditch. Then I turn off the highway and call on my friend Jake Serna—a representative northern New Mexican with Native American and Hispanic roots.

As soon as I reach Jake's place and get out of my car, I tread lightly. To me, this land is as sacrosanct as a camposanto. The adobe home that Jake and his wife, Barbara, built is perched on top of a high spot overlooking the Los Luceros land grant. Long ago, tribal people lived on the Sernas' property and left their traces—pottery shards, bone, and broken pieces of metates, the flat stones used for grinding corn. History litters the ground. After a rainstorm, these fragments of long-ago cultures and lives erupt from the earth as if to remind the present of the past.

Most people, even those from nearby, have forgotten those first New Mexicans who were here centuries ago, years before the coming of the Spanish and Anglos. Jake honors their memory. This parcel of land has attracted him since he was a child. He knows and loves every inch of it and can feel all the spirits that dwell in the earth.

Jake is a bilingual poet and a potter. He is a respected *santero*, a wood-carver who creates statues or images of holy persons from native wood. With roots firmly anchored in the northern New Mexico soil, Jake believes in preserving traditional values and culture while remaining a person of his own time. His lineage in Spain, Mexico, and New Mexico reaches far back on both sides of his family.

Born near Hernandez, a village on the other side of the Río Grande made famous by an Ansel Adams photograph of the moon rising there, Jake has the full and proper name of Jacobo de la Serna. His father's people came to northern New Mexico during the reconquest of the Pueblos in the late 1600s. One ancestor was a land-grant captain—Cristóbal de la Serna, who led an expedition against the Navajo in 1716. In 1748, with his wife, Josefa Madrid, he applied for a land grant in the Valley of Taos.

Jacobo's family—like other Spanish colonists who came to this land as conquerors—adapted to their new home. Soldiers and the sons and daughters of conquistadores evolved into ranchers and farmers. The soft chamois, or buckskin hide of deer and antelope, called *gamuza*, replaced expensive clothing of velvet and lace with gold trim. Oils on canvas, ivory

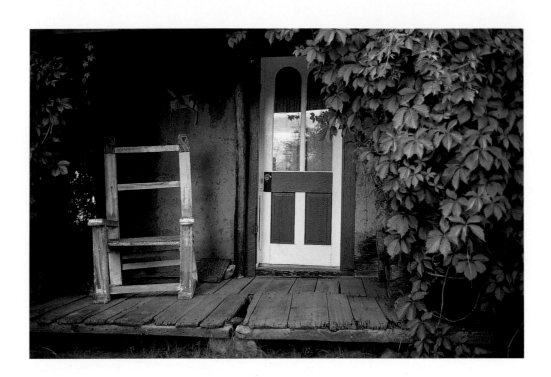

The D. H. Lawrence Ranch in San Cristobal north of Taos, where Lawrence
lived with his wife, Frieda, from 1922 to 1925.

crucifixes, mahogany sacristy chests, and extravagant cathedral candlesticks did not fit in with the El Norte lifestyle. Those things eventually gave way to the more humble carved and painted santos, saints. These bultos, statues, and retablos, paintings on pine boards or tin with religious themes, were fashioned for village churches and homes.

The santos also found their way into the moradas, or meeting places, of the lay religious brotherhood found exclusively in this region. It is commonly known as Los Hermanos Penitentes, the Penitent Brothers, or simply Los Hermanos. The Penitentes' origins remain shrouded in mystery, and their private ceremonies are frequently misunderstood. Yet their preservation of New Mexico's cultural heritage is undeniable. Throughout this land—the Mora Valley, along the Río Grande and Río Chama, at the villages dotting the High Road to Taos, and across the Taos Valley—the Brothers and their families keep hope alive as they quietly practice their faith. They care for those in need, they pray and sing, and they speak to saints, angels, and dead ancestors.

Handmade saints, earthen pottery, and people of strong faith—that is what I discuss with my friend Jacobo de la Serna in the midst of my journey to Taos. He is a man who cherishes the heavenly light of the region and is pleased to carry on the work of the past.

Jacobo picks up a handful of earth and rubs it between his palms. His maternal great-grandmother, a Navajo, was also a potter. Lovingly called Mama Luna, or Mother Moon, she is long gone, but her memory through family stories guides Jacobo as he takes up clay and earth from across northern New Mexico and creates works of art. A chili pot she made ages ago is one of Jacobo's most prized possessions. It dawns on me that this place has come full circle. A potter now lives and works on a site where so many other potters once resided. Pieces of Jacobo's life and work form another layer of history.

"I believe my great-grandmother guides my hand, and I try to bring honor to my family whenever I create," Jacobo tells me. "I feel that being a *santero* and a potter is very important, so I keep this in mind when I go up in the mountains and find the micaceous clay I use to create my pottery. Once I locate a vein, I lay down my prayers and make an offering of tobacco or corn meal. Our people—both Native American and Hispanic—need to keep alive as many traditions and aspects of our cultures as possible.

"An assimilation process immersed us for many years in northern New Mexico. It took a toll on our culture. Look around us and see the mobile homes and clapboard houses. There has been a role reversal. Now the Anglos come in and buy the old adobe home and save it. They have saved our architecture while our people often ignore it. Yet here on my roost, I look at the mobile homes moving in but I try to see them in a different light —the light of the present."

We watch massive Old Testament clouds congregate like nameless monuments in the brilliant sky. As I scan the tapestry of sky above and watch the play of brilliant light on the landscape, I know why I think of northern New Mexico as heaven's window. We speak of other times when the clouds were not soft and white and the blue sky turned gray and foul smoke hung in the air. We recall the spring of 2000, when the great Cerro Grande fire, named for a mountain peak, swept over the city of Los Alamos—the once-secret birthplace of the atom bomb.

Nestled in the Jemez Mountains, Los Alamos is pure government issue. The city was created during World War II as a gathering place for scientists to come up with the massive weapons of destruction used to obliterate two Japanese cities, kill tens of thousands of people, and effectively end the war in the Pacific. It remains a company town with a nuclear-weapons laboratory, research facilities, and hazardous-waste area. Oddly enough, workers use

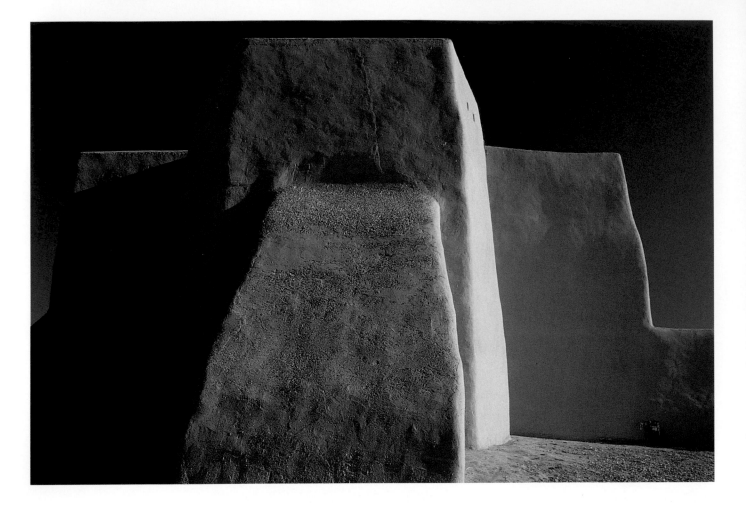

The Church of San Francisco de Assis in Ranchos de Taos is one of the most photographed sights in northern New Mexico.

the word *kiva*—after the Pueblos' sacred ceremonial chamber—to describe the fireproof concrete bunkers loaded with explosives and radioactive materials.

For me, Los Alamos is a most ironic place. This city that spawned such horrific fires of sheer destruction occupies a series of mesas created thousands of years ago by fingers of lava flowing from a volcano. A nearby crater, now a 176-square-mile grassy valley known as the Valle Grande, is stark testament to the power of the extinct volcano.

The ironies do not stop with the city's location.

There is the question of the name—Los Alamos, "the cottonwoods." This city of nuclear weapons takes its name from trees that symbolize life in this land. Likewise,

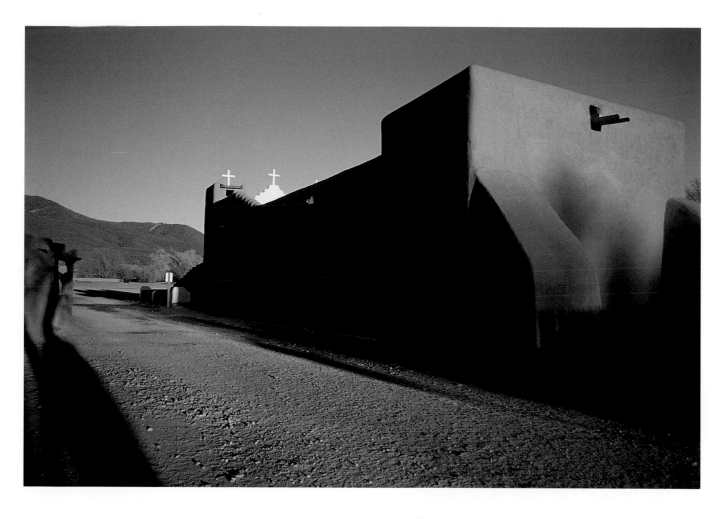

San Geronimo de Taos church at the Taos Pueblo is at the foothills of
the Sangre de Cristo Mountains.

Alamogordo, "large cottonwood," is the name of the southeastern New Mexico town near where the first atomic-device test took place—a rehearsal for the big show.

Perhaps the most obvious irony of all was that terrible forest fire of 2000. The tremendous blaze that eventually threatened important historic ruins, archaeological sites, and nearby pueblos started as a prescribed burn, set deliberately by the U.S. Park Service as a fire-prevention measure. Thousands of acres burned, many homes were destroyed, and Los Alamos remained under siege as relentless winds fanned the flames. The fierce conflagration melted car grilles and warped windows into shapes like glass sculptures.

Eventually, firefighters extinguished the blaze. Thousands of evacuees returned to scorched Los Alamos and streets lined with the surviving brick and frame homes that look as though they belong in suburban Cleveland.

While the distant fire still ravaged the landscape, Jacobo Serna watched from his adobe. The night sky glowed with the pulsing orange flames. To Jacobo, it looked like the end of the world. Smoke and ash floated from the heavens over Española, over San Juan, over Los Luceros, and over Jacobo's hilltop home. A foul fog hung above apple and apricot orchards and drifted toward the mouth of the canyon that leads to Taos.

Horses run through Taos Pueblo on a winter afternoon.

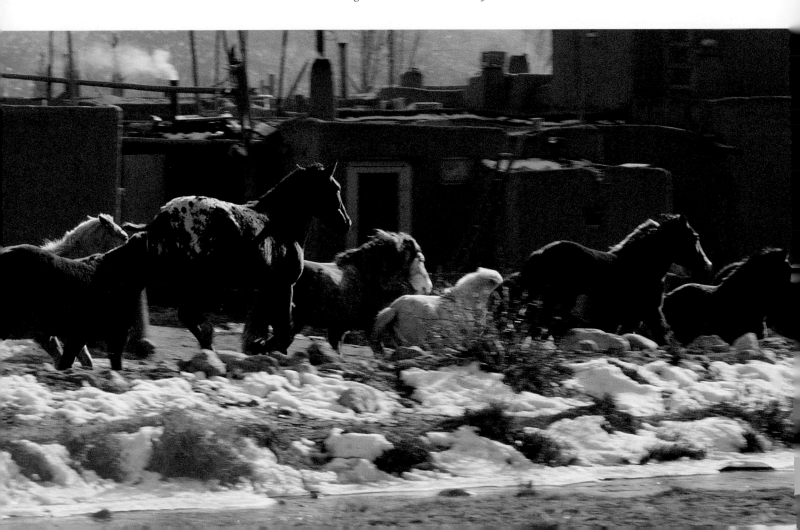

Jacobo and I silently give thanks for clear skies, and I take my leave. My car descends the bumpy driveway to the dirt road and then to the pavement, and I am again headed north on the Taos Highway. I consider Jacobo's good luck and the inspiration that surrounds him—the acequia, the fields, his view of the Truchas Peaks, the spirit of Mama Luna, and the layers of history that never change just below the surface of the here and now. Throughout northern New Mexico, the resistance to change intrigues me as do the various contrasts, both subtle and obvious, that I find wherever I look. Sometimes the two—change and contrast—mingle as one.

A prime example of the blending of contrast and change is how the people of northern New Mexico choose to live. At Taos Pueblo, for example, some inhabitants resist modernization. They still bake daily bread outdoors in *hornos*—ovens shaped like beehives. Yet a fashionably attired college student arrives in a new automobile and scrambles up a wooden ladder to her high-rise residence. The past, present, and future come together.

Elsewhere in the northern highlands, where villagers sculpted buildings from plastered adobe bricks fashioned from handfuls of native earth, there is another kind of change and contrast. In some places, adobe is no longer the most popular building material. Cement-block homes covered with a plaster veneer to look like adobe are in style. They are easier and less expensive to build. And just as my friend Jacobo pointed out, much of the new housing in the rural region of the north consists of trailers. So I am thankful each time I see a freshly plastered house or a wrinkled old adobe building.

Although the funky town causes me much despair when ski traffic clogs the main road, my heart sings in Taos. This is the home of some of my favorite adobe buildings—historic sites, residences, and churches. Nearby is the great pueblo with its honeycomb of dwellings rising against the backdrop of mystical Taos Mountain—known by the Pueblo people as the gateway to heaven. But even more important, Taos is also the home of many treasured New Mexicans—past and present.

I will never forget the first time I came to Taos. It was January 1, 1970. For many of us, that date meant adios to the 1960s and greetings to a brand-new decade. I had lived in New Mexico for a while but had not yet visited Taos. The time had arrived. With my true love, Suzanne, I climbed into the back of a battered Chevy pickup in Santa Fe and struck out for Taos with friends. Some of us donned remnants of our recently shed military uniforms. Others wore cloaks, plumed hats, colorful caps, and mittens. Between us, we had a few

dollars, a couple of old blankets, a jug of rum, and a lot of hope. I can see a tarot card —the Fool—dangling from the pickup's rearview mirror. Because the temperature was bitterly cold and snow covered the ground, we bypassed the High Road loop. We sped north on the Taos Highway through Española and the canyons and rock walls flanking the icy Río Grande.

That first journey to Taos was a quest for my friends and me. We hoped to find a woman we had heard about. We believed she could help us understand all we needed to know about how to start a renaissance. All of us were young, idealistic, loaded with optimism and, as the tarot card reminded us, a bit foolish. No challenge seemed too great, including a seventy-five-mile ride on a frigid winter's day in the back of a pickup, the task of finding shelter for the night, or the rather lofty notion that we could somehow launch a cultural movement.

I knew even then that Taos has always been a haven for a diversity of people. Taos Pueblo dates back more than one thousand years, and Spanish colonists founded the nearby town of Taos early in the seventeenth century. After the Pueblo Rebellion of 1680 and the Spanish reconquest that followed, Taos became a popular trade center for all sorts of folks, including Jacobo de la Serna's ancestors. Visitors ranged from Ute warriors wearing great necklaces of grizzly-bear claws and scalp-hunting Comanches bringing slaves to market to wild-eyed mountain men and foul-smelling trappers thirsty for a jolt from the potent whiskey known far and wide as Taos Lightning. Señora Gertrudis Barceló, or La Tules, spent some time in Taos before setting up her gambling enterprise in Santa Fe, and Christopher "Kit" Carson called Taos home. The scout and Indian fighter lies buried in a town cemetery that bears his name.

The rich and colorful past of Taos fascinated me, especially the town's evolution from an ancient settlement of firm cultural roots into a significant arts center and a colony for painters and writers. That began in 1898 when Ernest Blumenschein and Bert Phillips, with their imaginations fueled by glowing reports from fellow artist Joseph Henry Sharp, journeyed through New Mexico.

Just thirty miles north of the Taos valley, a wheel on their rickety wagon broke. On the flip of a three-dollar gold piece, Blumenschein got the job of riding horseback with the broken wheel to the nearest town for repairs. The town was Taos. Enchanted by the village and the sheer beauty of the area, Blumenschein and Phillips decided to make Taos their home. Later, Sharp joined them, followed by several other notable artists who helped organize the Taos Society of Artists. The broken wheel became the symbol for the art colony.

In the following years, all species of painters, sculptors, poets, playwrights, novelists, actors, and composers showed up in Taos. All of them wished to find out if the mysterious dark mountains and the surrounding mesas studded with fragrant sagebrush, which had inspired the First Peoples for generations, would also cause their creative sap to rise and flow. For some, it worked; for others, it ended in disaster.

From my reading and the tales I had heard, I knew that an assortment of wisdom keepers lived in Taos, not just at the ancient pueblo but also scattered throughout the town. But on this first day of a fresh decade, my friends and I in the pickup truck raced on in the dying sunlight looking for only one—an elderly, deaf painter named Dorothy Brett.

Although she had lived as an artist in Taos since the 1920s, the woman we sought had begun her life during a time that seemed light-years before, in the stately court of Queen Victoria of England. Born in 1883, Dorothy Eugenie Brett grew up in Victorian aristocracy. She was the first daughter of Reginald Baliol Brett, Viscount Esher, a member of Parliament and adviser to the old monarch.

Brett's father organized the coronation of King Edward VII, in 1902, and the next year, Brett made her debut at court. One of her first escorts was young Winston Churchill, recently returned from the Boer War. It was not a pleasant experience. Brett found Churchill offensive and rude. In addition, the young lady was beginning to lose her hearing, and the rather large brass ear trumpet she later named Toby made her the object of ridicule in upper-class British society.

Much to the chagrin of her family, young Brett followed her heart and enrolled at London's Slade School of Art. After four years of training, she developed an unconventional style of painting that combined the visionary world with a manner largely her own. She also established a new and unorthodox set of friends—including Katherine Mansfield, Middleton Murray, Aldous Huxley, Virginia Woolf, and Bertrand Russell. Brett found their company much more to her liking than the stuffy types she had had to endure in royal circles.

Brett had been introduced to the English novelist D. H. Lawrence in London in 1915. They immediately became close friends. As Brett later told me, "Something sparked between us." Lawrence eased Brett's painful shyness, and she felt that time spent with him was "almost unbearably exciting." At the time, Lawrence was beginning to attract attention in literary circles, but he suffered from tuberculosis and sought relief through quixotic wanderings around the world. Because of his traveling, Lawrence and Brett did not see each other until 1923, when Lawrence and his wife, Frieda, returned to Great Britain from the United States.

An orchard rests in winter in Valdez, outside of Taos.

The Lawrences had been living at Taos, the cultural domain of Mabel Dodge Luhan, who lured artists and others to the large home she shared with her husband, Tony Luhan, a Taos Indian. Despite the tension that developed between the Lawrences and their hostess, the temperamental writer believed New Mexico could be fertile ground for his so-called Rananim— a utopian community of artists.

"I think New Mexico was the greatest experience from the outside world that I have ever had," wrote Lawrence. "It certainly changed me forever. . . . The moment I saw the brilliant proud morning shine high up over the deserts of Santa Fe, something stood still in my soul, and I started to attend. . . . In the magnificent fierce morning of New Mexico one sprang awake, a new part of the soul woke up suddenly, and the old world gave way to the new." In a letter to a friend about his concept of Rananim, Lawrence explained the colony he planned. He described it as one "based, not on poverty but on riches, not on humility but on pride, not on sacrifice but upon complete fulfillment in the flesh of all strong desire, not in heaven but on earth."

In 1924, at what was portrayed as a "last supper" at the Café Royal in London, Lawrence plied a gathering of his friends with his fiery charisma and plenty of strong drink. He described Taos as "one of the magnetic centers of the world" and convinced them of a Rananim's importance. By the end of the evening, every person present vowed to go to Taos with Lawrence. Later that year, when the ship finally sailed to the United States, the Lawrences had only one colonist with them—Brett.

It proved to be a journey that lasted a lifetime for Brett. Her planned six-month visit to Taos never ended. That is what drew me to her in Taos on New Year's Day 1970. My friends and I wanted to know whether she had found that Rananim, and how, with the Lawrences, she had fueled her creative spirit.

After reaching Taos, we spent a less than idyllic New Year's night shivering beneath thin blankets and in borrowed sleeping bags on the hard earthen floor of a hippie commune. After what seemed an eternity, the darkness lifted. We ventured into the morning sunlight and pushed the pickup down a snow-crusted road to jump-start the cold engine. Then my band of dreamers struck out for Brett's home in El Prado, a settlement just a few miles northwest of Taos. We found her at home. She wore baggy pants and a brightly colored coat belted at the waist. Her snow-white hair stood in fluffy wisps and her bright eyes danced from face to face.

We introduced ourselves and pulled off our coats and hats in Brett's studio, which was cluttered with easels, canvases in various stages, tubes of paint, brushes, and piles of books. Brett informed us that she had finished painting for the day and graciously welcomed us into a circular room filled with sunlight. There was also a divan, a brass bed, bookcases, and a television draped with a cloth. We stepped over large soup bones strewn on the floor. Brett informed us that the bones belonged to her graying dachshund, Reggie, named for her distinguished father. We sat around her like students encircling a great teacher. As she stroked Reggie's head, Brett and I began a conversation that would continue off and on for more than seven years.

She spoke of coming to Taos with the Lawrences, and of the turbulent times with Mabel Dodge Luhan and the multitude of artistic characters who flocked to the mountain town. Brett thought the idea of some youthful idealists starting a renaissance was perfectly sound. She made suggestions about how to launch such a creative and cultural reawakening. She said that just the process of attempting to start a revival could be rewarding and useful, even if it never took hold.

Brett also shared her opinions about the pros and cons of a Rananim. She said the utopia Lawrence wanted to create never became a reality, but that did not halt or hinder the creative process. Her thoughts of communal living, however, had changed over the years. "I no longer think utopias work," Brett told us. "After a few months of close living, squabbling begins. People should live apart and do their work—their writing, painting, composing—and then gather at certain times to share and discuss their ideas, and nourish one another. Where this gathering takes place doesn't really matter."

We visited with Brett all afternoon and returned to Santa Fe inspired. Taking Brett's advice to heart, we maintained our ties but pursued our creative dreams as individuals. Through the years, I continued to visit Brett at her home and learn more about her relationship with Lawrence and her life in Taos.

When I visited Brett, I always took her some sweets or a handful of sunflowers, and we sat in the circular room and talked. Sometimes I used a small tape recorder to capture her stories. I found that although she spoke of the past, she also lived very much in the present.

"It is very important for some things to change," Brett told me. "Change is constant, and certainly not all change is bad. This land, for example, has always been invaded and sometimes the invaders have made contributions with the changes they brought with them. . . . Thankfully, many of the people who should not be here cannot adjust to this land, to this place, and they leave. The land seems to belch them out."

I looked forward to my afternoons with Brett and seeing her works in progress. I especially liked her oil portraits of graceful Pueblo dancers. I never tired of hearing her speak, with eyes flashing, of the issues of the day. Most of the time, however, with my gentle prodding, Brett told me of the old times—the long-ago days spent with D. H. Lawrence, Frieda, Mabel, and all the others. I longed to know of those who came before me and dealt with this land and the people and left their legacy of art, prose, and poetry.

As Brett talked, I occasionally pictured her as a younger woman in her big Stetson hat, stalking around the countryside with a dagger tucked in her boot, overcoming her fear of a new and strange place. I thought of how she had fallen in love with northern New Mexico, just as Lawrence did, even though he spent only a total of eighteen months living in Taos. I recalled how he wrote about his passion for the land:

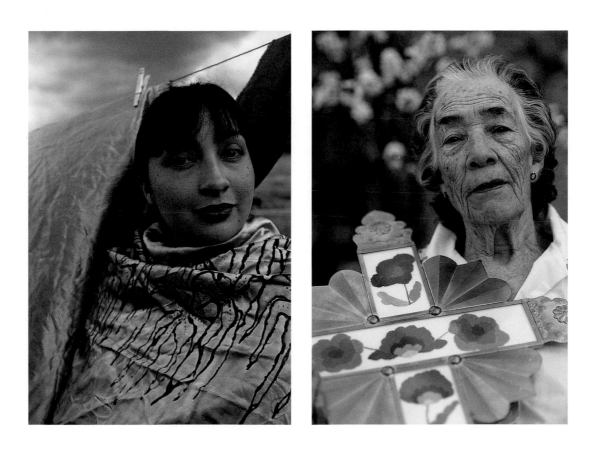

(Left) Patricia Michaels, a fashion designer from Taos Pueblo, and (right) Senaida Romero, colcha weaver and tin worker.

But for a greatness of beauty I have never experienced anything like New Mexico. All those mornings when I went with a hoe along the ditch to the cañon, at the ranch, and stood, in the fierce, proud silence of the Rockies, on their foothills, to look far over the desert to the blue mountains away in Arizona, blue as chalcedony, with the sagebrush desert sweeping grey-blue in between . . . the vast amphitheatre of lofty, indomitable desert, sweeping round to the ponderous Sangre de Cristo mountains on the east, and coming flush at the pine-dotted foothills of the Rockies! What splendour!

In that vivid description of New Mexico, the ranch that Lawrence wrote of was a 160-acre spread located eighteen miles north of Taos on the slopes of Lobo Mountain in the Sangre de Cristos. Mabel Dodge Luhan gave the ranch to Frieda in exchange for the manuscript of Lawrence's novel *Sons and Lovers*. It was originally called the Flying Heart Ranch, but Lawrence renamed it Lobo Ranch and then Kiowa Ranch. When Mabel's hospitality wore thin at her big house in Taos and the Lawrences craved a more independent lifestyle, the ranch proved to be an ideal refuge.

Instead of writing at the ranch, Lawrence mostly busied himself with outdoor chores such as chopping wood with a heavy double-headed ax, milking Susan the cow, and baking bread and chickens in an *horno*. He also spent much of his time fishing or riding horseback to the distant Río Grande and over mountain trails. During my visits with Brett, she enjoyed recalling all the good times spent at the small log cabin beneath the pines on Kiowa Ranch. She told me those were some of Lawrence's happiest days, perhaps the closest he came to finding that elusive Rananim.

In September 1925, Lawrence — filled with the wanderlust that many tuberculars experience — left the ranch behind. After he died in 1930 at age forty-four, Frieda returned to the ranch and had his ashes mixed into the wet cement that formed the altar in a shrine built on Lobo Mountain. And when Frieda died in 1956, she was buried nearby.

In the autumn of 1970, after many more trips to Taos and visits with Brett, I attended a D. H. Lawrence Festival sponsored by the University of New Mexico to mark the fortieth anniversary of Lawrence's death. Scholars from around the world showed up in Taos for receptions, art shows, films, and lectures. Most of the action took place at the Kiowa ranch. As a young writer just stretching my literary wings, I gulped down every word spoken and watched all the antics.

During a late-afternoon session, I sat alone about midway in the auditorium listening to the panel of experts seated on stage dissect Lawrence piece by piece. Suddenly I felt something brush against my legs. I looked down, and there was a large black cat with the greenest eyes I have ever seen. He looked up at me and then moved on beneath the chairs. I could see people seated in front of me react when he brushed against their legs. Soon the cat reached the front of the auditorium. He sat on his hind legs, looking imperious and wise as only cats can do. Then I noticed Helen Corke, a panelist on the stage, looking at the cat and smiling as though she had just encountered a long lost friend.

I knew that Helen Corke had been one of Lawrence's closest friends and confidantes all the way back to the early 1900s in England. They shared an interest in literature, music, and art. Lawrence took the young woman to the theater in London and accompanied her on long walks in the country. In 1911, the year after Lawrence's mother died, when he had a complete breakdown and was stricken with tubercular pneumonia, Helen Corke helped nurse him back to health. Lawrence based his second novel, *The Trespasser*—published in 1912—on Helen's tragic love affair with her married violin teacher. Lawrence had been the one who resurrected Helen when the affair ended and her forbidden lover committed suicide.

Now I watched Helen Corke smiling in her easy chair on the stage, and I thought about when her snow-white hair was red and she read poems a young Lawrence had written just for her. Suddenly, with the grace of a panther, the black cat leaped onto the stage and, with one more smooth bound, into Helen's soft lap. Without missing a beat, the old woman dropped her hand onto the cat's neck and stroked his back. He remained there until the panel ended. His green eyes never left her face.

Afterward, people milled about the big room and I went outside for fresh air. I decided to walk up the steep rock-lined path to Lawrence's shrine to pay my respects. As I neared the summit, I spied the white chapel and red roof and on top the large white phoenix bird, the symbol of resurrection and immortality that Lawrence had chosen for his own. Outside the shrine, I looked at Frieda's grave and her smiling photograph encased in the stone. Then I heard soft voices. Because of the wind, I was not sure where they came from, but then I listened and knew the voices came from inside Lawrence's shrine.

I slowly approached the open door and peeked inside. I saw the altar and candlesticks and the flowers and leaves Brett had painted years before. I also saw Helen Corke. She stood before the altar and gazed into the eyes of the black cat, sitting on the podium that held the guest book. The woman and the cat turned their heads as one and looked directly at me. Helen still had the same smile, and the cat's eyes gleamed. No one spoke. We stood motionless for what seemed like a long time, and then I turned and left without a word.

I walked down the pathway and knew that the conversation had started again inside the shrine. I also knew that I had just witnessed a reunion between two very old friends. The cliché is true—New Mexico is the land of enchantment.

✤

Dorothy Brett died in 1977. She was almost ninety-four years old and had outlived her beloved Lawrence by more than forty-seven years. She had outlived most of her friends and critics by decades. Her home and studio at El Prado became a restaurant named Brett House, and tourists and skiers came to dine on rich food. I knew the ghost of a plump dachshund gobbled up the scraps.

Through the years, the pals who came to Taos on that cold January day so long ago have moved in different directions across the world. We are writers, poets, painters, photographers, editors, and teachers. All of us are still dreamers. Every once in a while, we gather, often in a big city or in New Mexico, where it all began. In my home, among the creative clutter are photographs from that first day of 1970 and portraits of Brett.

And in my study hangs an old ax that D. H. Lawrence used to cut wood at Kiowa Ranch. His sweat and blood from blisters stain the splintered, taped handle. Brett gave me the ax before she died. She had taken it from the ranch years before. She knew that I would treasure it. She knew it would serve me well and remind me of the old magicians who taught me so much.

Other icons and mementos from northern New Mexico surround me. There is a vase holding Penitente weeds, smooth river stones, a bouquet of raven and hawk feathers, pieces of pottery and bone found at Los Luceros, wooden crosses and animals from the village carvers at Cordova, a handful of Chimayo's healing earth, gourd rattles, a coyote's skull, and so much more. It is divine loot. It is evidence to remind me that the threshold to heaven is here on earth.

Epilogue

*T*HE MOUNTAINS, especially the Sangre de Cristos, offer the best vantage point to view the mosaic of history and culture of northern New Mexico. Carl Jung was right to call this range "the roof of the American continent." Peaks where winds are born and rainbows hide appear to touch heaven, and the great shadows of the Sangres fall on land known as the dancing ground of the sun.

Nestled in the lower slopes, the valleys, and along the Río Grande are ancient pueblos, adobe villages, and towns. People who dwell there understand the language of clouds and believe in the wind. Generations of Pueblo Indians, descendants of Spanish colonists, and Anglo settlers have made the sprawling El Norte their home, giving this place a distinct character.

The Sangre de Cristos, the Jemez Mountains, and other surrounding ranges shape the Pueblo Indian homeland. The descendants of tribal people who dwelled in this land before all others still dance as one to the poetry of sacred song blended with the beat of drums. In the old Spanish mountain hamlets, where some residents cling to the ways of vanished ancestors, I still expect to hear the language of Cervantes.

Nothing I encounter in this land of *poco tiempo*—this land of little time—surprises me anymore. For that I am thankful.

Acknowledgments

———————

My lasting gratitude goes to Nicholas Potter, Clark Kimball, Zigy Kaluzny, Roger Hubert, Jacobo de la Serna, Harvey Van Sickle, Stephen Fox, Michael Martin Murphey, Lydia Wyckoff, and Shelby Tisdale. I also thank the staff of The Wallis Group, in particular Debra Silkman. Special thanks go to the team that put this book together, including my agent, Michael Carlisle; David Skolkin, the excellent designer; Hazel Rowena Mills, the most capable copy editor I know; and Ellen Wheat, Jean Andrews, Tim Frew, and Douglas Pfeiffer of Graphic Arts Center Publishing Company. A very important salute goes to my creative partner, Jack Parsons, the incomparable photographer whose stunning images bring so much life and meaning to this work. And my everlasting thanks go to my wife, Suzanne Fitzgerald Wallis, and to our constant muse and companion, Beatrice, the wisest of all literary felines.

—Michael Wallis

Special thanks go to the following for their help with this book: Bill Field and the Santa Fe Rotary Club, Manya Winsted and the *Santa Fean Magazine*, the Spanish Colonial Arts Society, Carmella Padilla, Robert and Rebecca Bluestone, Reed Callanan, and Diana Eilers. I am especially grateful to Tim Frew of Graphic Arts Center Publishing Company, who oversaw the production of this book, and to Joanna Hurley, a talented and diligent agent who always helped with good advice. Thanks also go to designer David Skolkin, whose superb eye added immeasurably to this project and to everything he has undertaken. Most importantly, my thanks go to Michael Wallis, who made it all happen and whose friendship and perceptive understanding of northern New Mexico made this project a delight. Finally, an unending debt of gratitude goes to my wife, Rebecca.

—Jack Parsons